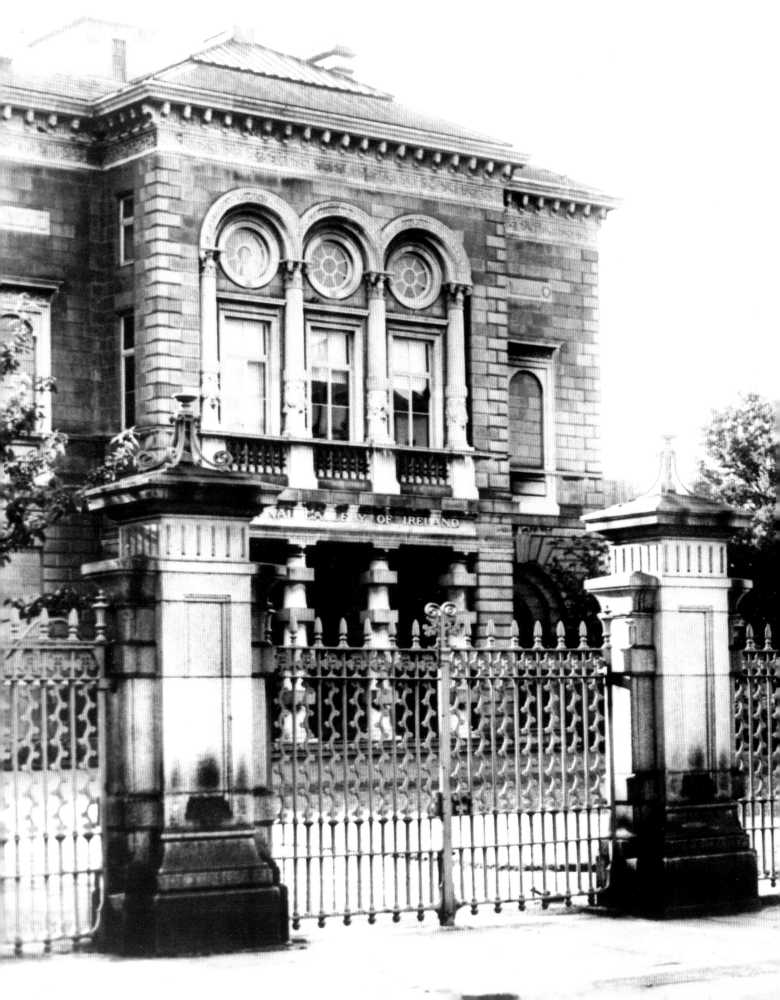

Samuel Beckett
A Passion for Paintings

NATIONAL GALLERY OF IRELAND

Published in conjunction with the exhibition,
Samuel Beckett: a passion for paintings
at the National Gallery of Ireland, Dublin
15 June – 17 September 2006

This project is grant-aided by the Department of Arts,
Sport and Tourism as part of the Beckett Centenary Festival

Distribution in Ireland by the National Gallery of Ireland
Worldwide distribution by Paul Holberton

ISBN 1-904288-16-2
ISBN 978-1-904288-16-9

Edited by Fionnuala Croke

Publication Assistants: Riann Coulter, Susan O'Connor
Copy Editor: Elizabeth Mayes

Catalogue Designed by Jason Ellams
Printed in Dublin by Hudson Killeen

Cover image: detail from fig. 20, p. 30

Frontispiece: exterior view of the National Gallery of Ireland
prior to the construction of the 1968 wing, National Gallery of
Ireland Archive

Foreword

For what is primarily a picture gallery, since its foundation in 1854, the National Gallery of Ireland has had an exceptional relationship with writers and dramatists. One of its earliest Directors, Henry Doyle, was uncle to Arthur Conan Doyle, the creator of Sherlock Holmes. James Stephens, author of *The Crock of Gold*, was Registrar at the time of the Easter Rising in 1916. He was succeeded in office by Brinsley McNamara, who in 1918 published the controversial novel, *The Valley of the Squinting Windows*. McNamara, in fact, presided as acting Director for a brief period, following the resignation of Lucius O'Callaghan in 1927. The poet and Nobel laureate, W.B. Yeats, was serving on the Board of Governors and Guardians at this time. Following the Second World War, Thomas MacGreevy, until then better known as a poet, was appointed Director. His great good fortune was to have at his disposal, during the latter years of his stewardship, the proceeds of George Bernard Shaw's exceptional benefaction to the Gallery. This singular act of generosity was prompted by a sense of gratitude which he felt he owed to the Merrion Square establishment. In a simple postcard written to Thomas Bodkin (a former Director) in 1944, Shaw noted his debt, stating his wish for part of his estate 'to go the National Gallery (your old shop) to which I owe the only real education I ever got as boy in Eire'.

Less well known, until relatively recently, is the very special relationship between the National Gallery and Samuel Beckett, whose writings and dramas are considered among the prime achievements of twentieth-century culture. Whilst Beckett received a thorough formal education and was not an autodidact in the manner of Shaw, the Gallery and its collection had a profound affect on his formation as an art lover, thinker and writer. His early familiarity with the works on display nurtured an appreciation of the visual arts, which later encouraged him to visit and engage with collections elsewhere, as well as generating a disposition to associate with painters and individuals involved in the world of art. Among his most important relationships in this respect were Thomas MacGreevy, whom he first met in Paris in 1928 and who introduced him to James Joyce and Jack B. Yeats.

These encounters not only enriched Beckett's personal life and his appreciation of art and artists, but also informed his work as a writer and dramatist. As demonstrated by many of the exhibits, and made clear in the various contributions to this publication, Beckett's artistic universe is frequently redolent of influences from the world of thc visual arts. Whilst the writer himself discouraged an overly analytical approach to his novels and theatre and preferred to let his works appeal directly to the sensibilities of his audience (and was hugely reluctant to 'explain' anything in his work) he did relent very occasionally, providing revealing insights into his creative process. The most notable and telling reference in this connection was his acknowledgement that the setting of *Waiting for Godot* was suggested by Casper David Friedrich's romantic masterpiece, *Two Men Contemplating the Moon*, which he would have seen during his sojourn in Germany in 1936-37. The diaries which he kept during his six month stay give testament to his great passion for paintings, a passion which is the central topic of this exhibition.

In mounting this show we are a particularly grateful to our colleagues from the world of literature and drama who have extended us every possible support and encouragement in presenting on a topic which is not normally in the domain of the fine art connoisseur. Most particularly we are grateful to Edward Beckett for his personal interest in this project which seeks to demonstrate the very particular relationship which existed between his uncle and the National Gallery of Ireland and world of the visual arts in general.

Raymond Keaveney
Director

Acknowledgements

The Exhibition *Samuel Beckett: a passion for paintings* was realised in an exceptionally short time, especially given the nature of the subject. From tentative beginnings the project has grown to encompass a wider and more ambitious remit than originally envisaged. Whilst the tight timeframe has limited what could be achieved, the project has delivered on much if not most of its potential: this is due to the enthusiastic commitment and assistance of colleagues and collaborators in Ireland and abroad, and we wish to acknowledge our very special debt of gratitude to all those who supported us in this voyage of discovery.

First and foremost, we are particularly indebted to Edward Beckett for his tremendous support and cooperation in bringing the project to fulfillment. The Exhibition and accompanying publication have been made possible with a grant-in-aid from the Department of Arts, Sports and Tourism, and we are most grateful for this generous support.

The Exhibition draws heavily on Samuel Beckett's letters to Thomas MacGreevy which more than almost any other source illustrate the writer's special relationship with the National Gallery of Ireland and his passion for paintings. For permission to quote from this correspondence we wish to thank Bernard Meehan and the Board of Trinity College Dublin.

For permission to reprint extracts from Beckett's prose and dramatic works we thank Rosica Colin Ltd., Faber & Faber Ltd., John Calder Publishers Ltd. and Grove Press Inc.'

In April 2006, the Gallery organised a Round Table discussion on the theme 'Beckett and the Visual Arts'. The panel of speakers comprised scholars, artists and a writer, who each addressed the theme from their varied standpoints. Their presentations, which are included in the present volume, constitute a valuable contribution to the growing literature on the subject. We wish to thank Peggy Phelan who chaired the session, together with each of the panellists: John Banville, Dellas Henke, Charles Klabunde, James Knowlson, Rémi Labrusse and Breon Mitchell. It was Lois Oppenheim who originally proposed the idea of a Round Table and she had set up the panel when, unfortunately, she was unable to travel to Dublin.

I would like to take this opportunity to acknowledge her contribution to the project which benefited enormously from her great knowledge and her enthusiastic support. I also wish to thank those colleagues at the National Gallery who assisted us with the organisation of the Round Table, most notably Marie Bourke, Lynn McGrane, Jim O'Callaghan, and Orla O'Brien.

This volume of essays is made up of contributions from authors who have worked to very tight deadlines and we would like to thank each one of them for sharing their knowledge and insights with our public: Nicholas Allen (Associate Professor of English and Irish Studies, University of North Carolina at Chapel Hill), James Knowlson (Emeritus Professor of French, and Founder of the Beckett International Foundation at the University of Reading), David Lloyd (Professor of English, University of Southern California), Lois Oppenheim (Professor and Chair, Department of Modern Languages and Literatures, Montclair State University), and Susan Schreibman (Assistant Dean, Head of Digital Collections and Research, McKeldin Library, University of Maryland).

The Exhibition could not have been realised without the generous support of each of the lenders to whom we are deeply grateful: Aargauer Kunsthaus, Aarau; The Beckett International Foundation, Reading University; Centre National d'Art Contemporain Georges Pompidou, Paris; The Chester Beatty Library, Dublin; Dublin City Gallery The Hugh Lane; Fondation Alberto et Annette Giacometti, Paris; Gemäldegalerie Neue Meister, Staatliche Kunstsammlungen, Dresden, Sligo Municipal Collection, The Model Arts and Niland Gallery, Sligo; Rijksmuseum, Amsterdam; Tate, London; and Ulster Museum, Belfast. We also acknowledge the cooperation of those lenders who wish to remain anonymous.

Others who have provided much appreciated assistance and advice are: Marianne Alphant, Michelle Archer, Avigdor Arikha, Bruce Arnold, Stéphanie Barbé, Lian Bell, Enoch Brater, Louis le Brocquy, Pierre le Brocquy, Terence Brown, Gerard Byrne, Anthony Cronin, André Derval, Margaret Farrington, Julian Garforth, Declan Kiberd, James Knowlson, Ronald de Leeuw, Ronan McDonald, Anna McMullen, Mark Nixon, Seán O'Mordha, Lois Oppenheim, Lois Overbeck, Michael Ryan, Robert Ryan, Joe Stanley, Mary Traester, Cindy van Weele, Véronique Wiesinger, Leslie Waddington, Theo Waddington, and Beat Wismer.

Two colleagues deserve special mention. Riann Coulter has been working as a freelance art historian on this project and her contribution has been invaluable. She has also written an introduction to the Exhibition in this volume. At the National Gallery of Ireland Susan O'Connor (Exhibitions Officer) has provided, as always, tremendous administrative support. They have both worked tirelessly to ensure that the Round Table, the Exhibition and this accompanying publication have been completed on time. Bill Maxwell has, from the beginning, been a source of wisdom and encouragement. I wish to particularly thank the following colleagues in the National Gallery of Ireland: Leah Benson, Síle Boylan, Ranson Davey, Sheila Dooley, Lydia Furlong, Mark Geraghty, Adrian Le Harivel, Roy Hewson, Anne Hodge, Roisin Kennedy, Kevin Kelly, Valerie Keogh, Andrea Lydon, Pat McBride, Marie McFeely, Niamh McNally, Andrew Moore, Louise Morgan, Orla O'Brien, Catherine Sheridan, Kim Smit, Felicia Tan and Ele Von Monschaw.

Fionnuala Croke
Head of Exhibitions
National Gallery of Ireland

Introduction to the exhibition: part 1

Fionnuala Croke

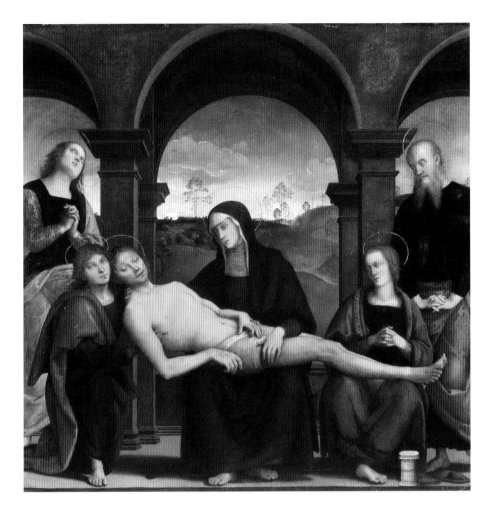

Fig. 1: Pietro Perugino,
*The Lamentation over
the Dead Christ*, c.1495,
egg tempera and
oil on panel,
169.5 x 171.5 cm,
National Gallery of
Ireland

Several Beckett scholars, most notably James Knowlson and Lois Oppenheim, have explored the importance of the Old Masters and of modern art on Beckett's writing. Beckett's great love for the National Gallery of Ireland and its collection, however, is not widely known. For these insights we are indebted to Beckett's correspondence with Thomas MacGreevy. It was MacGreevy, too, who encouraged the young writer to introduce himself to Jack B. Yeats, and all three men remained lifelong friends. The exhibition, *Samuel Beckett: a passion for paintings* thus begins by attempting to visualise these three relationships in the writer's life: with the Gallery, with MacGreevy, and with Jack Yeats.

Samuel Beckett and the National Gallery of Ireland

Beckett began his studies in Trinity College in 1923 and he visited the National Gallery of Ireland regularly both as a student and later as a lecturer.[1] His father's offices were just around the corner from the Gallery, at No. 6, Clare Street. Close by there is a gate into the grounds of Trinity College.[2] To walk the short distance from here to his Italian classes in the private language school at No. 21, Ely Place, Beckett would have passed the Gallery's gates. It is clear that the Gallery became a regular port of call, at a time when visitors were infrequent, and Beckett could be guaranteed the peace and quiet conducive to the contemplation of the works of art. The Gallery was a haven for him, and a sense of solitude was an essential element in his experience: one rainy day in the late 1930s, too many visitors caused him to complain that he 'couldn't rest before anything. It was fuller than I ever saw it, Americans mostly, & a sprinkling of the surprised without coats & umbrellas'.[3]

Beckett became intimate with the collection. He grew to love certain paintings (he had a preference for the Dutch

School), he kept an eye out for new acquisitions, and he was never short of an opinion, whether it was favourable or not. His comments on individual works were informed and insightful and, with the benefit of hindsight, his dismissal of an attribution has sometimes proved to be correct.[4]

His freely expressed comments and reactions are preserved in his correspondence with Thomas MacGreevy, his great friend who became Director of the National Gallery of Ireland (1950-63).[5] These references to the Gallery leave us in no doubt of Beckett's love of the Old Masters, nor of his astute critical eye, and as he frequented galleries in London, Berlin and Paris, he revealed this quality time and again. Indeed, his ability to compare works seen in different galleries, often years apart, led Knowlson to the conclusion that Beckett had a photographic memory.[6]

Although not formally educated in the visual arts, the young Beckett was serious about art, and in 1933 he even applied for a post as assistant in the National Gallery, London, using Jack Yeats as one of his referees.[7] When Dublin's newly acquired *Pietà* by Perugino (fig. 1) went on display at the end of November 1931, Beckett went to see it immediately, and returned 'several times'.[8] The picture

Fig. 2:
South Wall of Main Gallery in 1864 wing, c. 1930 (showing the Antoniazzo Romano, Paolo Uccello, Silvestro dei'Gherarducci, and Perugino), National Gallery of Ireland Archive

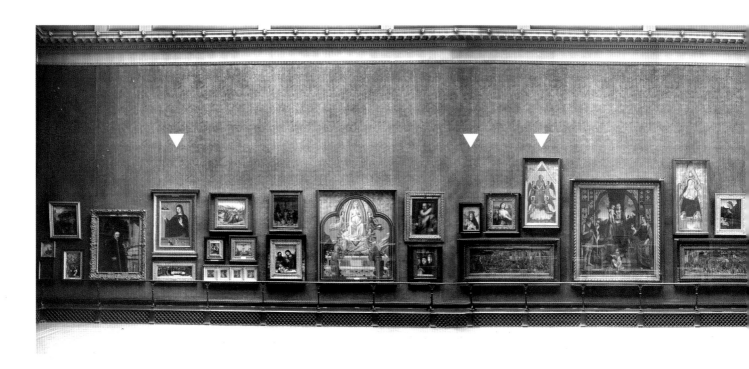

was hanging in the main upper gallery of the 1864 wing, in what is today referred to as the Baroque Gallery, and as we can see from a contemporary photograph (fig. 2) the panel was housed in a heavily glazed frame, to Beckett's considerable annoyance: 'It's buried behind a formidable barrage of shining glass, so that one is obliged to take cognisance of it progressively, square inch, by square inch'.[9] To drive the point home, he adds that it was 'Rottenly hung in rotten light behind this thick shop window, so that a total view of it is impossible'. In spite of this, he found that:

> … the Xist and the women are lovely. A clean-shaven, potent Xist, and a passion of tears for the waste. The most mystical constituent is the ointment pot that was probably added by Raffaela … a lovely cheery Xist full of sperm & and the woman touching his thighs and mourning his secrets.

No doubt viewing of the painting was not helped by its uneven condition. In his typically confident style of writing about the Gallery's paintings, Beckett tells MacGreevy that 'it's all messed up by restorers … and full of grotesque amendments'. In fact, the panel's condition was a

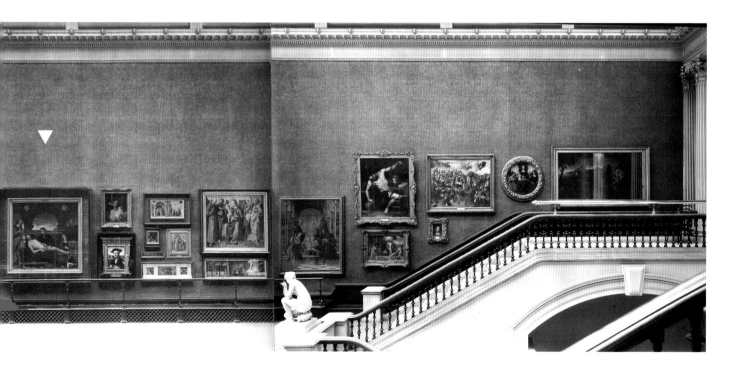

cause for concern, and it was sent first to the National Gallery, London for X-ray in July 1936, and then to the Kunsthistorisches Museum in Vienna for restoration.[10] Beckett noted its absence from the Gallery during a visit shortly after his return from Germany in 1937 ('The big Perugino has gone to Vienna "for examination"'[11]). A few months later, he records that it was back again, sadly, in his opinion, 'overcleaned'.[12]

It is perhaps not surprising that the picture was in Beckett's mind when he was writing 'Love and Lethe', one of the short stories included in *More Pricks than Kicks* in 1934.[13] Belacqua's girlfriend, Ruby Tough from Irishtown, is likened to Perugino's Mary Magdalene:

> Those who are in the least curious to know what she looked like at the time in which we have chosen to cull her we venture to refer to the Magdalene in the Perugino Pietà in the National Gallery of Dublin, always bearing in mind that the hair of our heroine is black and not ginger.[14]

There is also the following footnote on the word Magdalene, which echoes his words to MacGreevy just over a year earlier:

> This figure, owing to the glittering vitrine behind which the canvas cowers, can only be apprehended in sections. Patience, however, and a retentive memory have been known to elicit a total statement approximating to the intention of the painter.[15]

Patience, and a retentive memory; is this, then, how Beckett approached a painting as he sought to understand it fully?[16]

Other paintings from the Gallery are cited, either directly or indirectly in this collection of short stories.[17] In 'Ding Dong' he refers to the *Portrait of a Woman* then attributed to The Master of Tired Eyes (fig. 3).[18] He had made particular mention of this portrait in a letter in 1932 'I seem to spend a lot of time in the National Gallery, looking at the Poussin Entombment and coming stealthily down the stairs into the charming toy brightness of the German room to the Breughels and the Masters of Tired

Eyes and Silver Windows'[19] and he is reminded of it when describing the hatless pedlar woman:

> But her face, ah her face, was what Belacqua had rather refer to as her countenance, it was so full of light. This she lifted up upon him and no error. Brimful of light and serene, serenissime, it bore no trace of suffering, and in this alone it might be said to be a notable face. Yet like tormented faces that he had seen, like the face in the National Gallery in Merrion Square by the Master of Tired Eyes, it seemed to have come a long way and subtend an infinitely narrow angle of affliction, as eyes focus a star. The features were null, only luminous, impassive and secure, petrified in radiance …[20]

Although less obvious, in 'A Wet Night', he seems to make reference to Uccello's *Virgin and Child*[21] (fig. 4) when he writes:

> It was just a vague impression, it was merely that she looked, with that strange limey hobnailed texture of complexion, so frescosa, from the waist up, my dear, with that distempered cobalt modesty-piece, a positive gem of ravished Quattrocento, a positive jewel, my dear, of sweaty Big Tom.[22]

The head of the Virgin in the Uccello that Beckett knew was shrouded in a dark blue veil and although in this quote he does not actually mention an artist's name, the 'distempered cobalt modesty-piece' may identify with this early addition (possibly made in the seventeenth century) that was only removed in the late 1960s during restoration. We can see the panel as Beckett would have in the photograph of the main upper gallery of the Dargan Wing dating to the early 1930s (fig. 2). However, he might equally have been referring to the Antoniazzo Romano, *Virgin invoking God to heal the hand of Pope Leo I* (fig. 5), which was also displayed, on the same wall, at the time.[23]

When Thomas Bodkin resigned as Director in 1934, one of the candidates to replace him was none other than Thomas MacGreevy. In May, Beckett wrote to his friend:

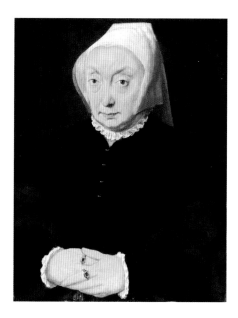

Fig. 3: Flemish School, *Portrait of a Woman*, c. 1540, oil on panel, 31.1 x 24.1 cm, National Gallery of Ireland

Fig. 4: Paolo Uccello, *Virgin & Child*, c.1435-40, egg tempera on panel, 62.3 x 41.1 cm, National Gallery of Ireland

Fig. 5: Antoniazzo Romano, *The Virgin invoking God to heal the hand of Pope Leo I*, c.1475, egg tempera and gold leaf on panel, 110 x 80 cm, National Gallery of Ireland

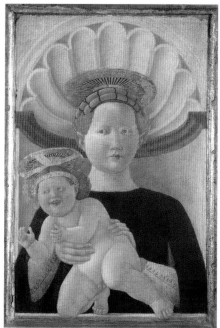

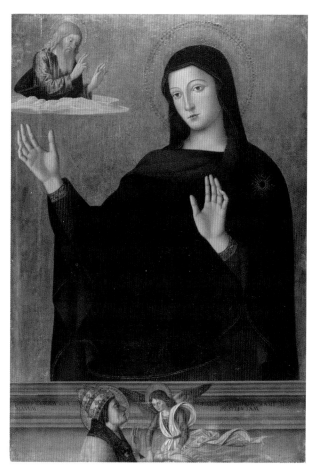

Do not allow the insignificance of the Merrion Squarers to prevent you from applying. After all it is the job, not the position that concerns you. If there are two parties in the electorate, & two equally supported candidates, you might easily get elected in a gust of spite.[24]

However, in July 1935 George Furlong was offered the post (and it was to be another fifteen years before MacGreevy was appointed Director). In subsequent letters, Beckett keeps his friend abreast of Furlong's acquisitions and plans:

I was talking to a Custodian in the Gal[l]ery, who said they would all die for Furlong with the greatest of pleasure. His diligence does not yet appear in the public rooms, but it appears he has gone through the cellar with a fine comb …[25]

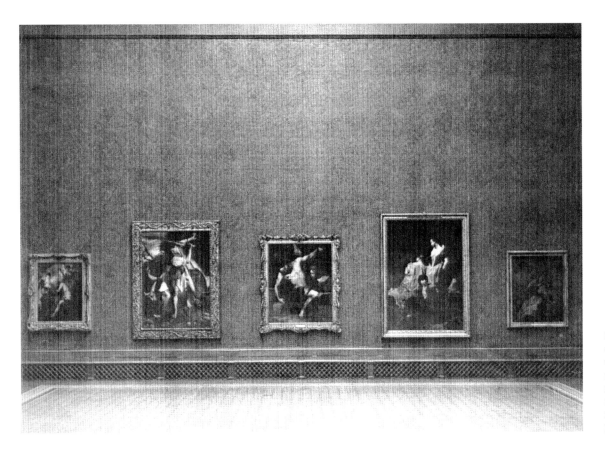

Fig. 6: End or East Wall of Main Gallery in 1864 wing, c. 1936, showing the Gentileschi (second from left) and Piazzetta (second from right), National Gallery of Ireland Archive

Over the next few months he becomes increasingly critical of Furlong's acquisitions. The new Gentileschi is 'awful' and 'appalling'.[26] Two paintings by Giuseppe Bazzani (*Christ Meets His Mother* and *The Descent from the Cross*) and *The Vision of St Jerome* purchased as a Jan Lys are 'really appalling'.[27] And although he approved of a new Morisot,[28] when Beckett went to see the fifteenth-century *Apostles Bidding Farewell* by a master of the Styrian School,[29] we are reminded of his dislike of the use of protective glass:

> Another new work, vaguely Austrian primitive,
> a panel painted both sides, on one Veronica's Sudarium,
> on the other the 12 in a strange scene. The magnificent
> glass case in which it is exposed, in centre of floor
> of Brouwer's room, cost £50. Good old Furlong.[30]

In the same letter, he tells MacGreevy of Furlong's plans to remove all the Dutch pictures to the print room to make more room for the Italian works, in a single line hang. In fact, immediately upon taking up his appointment,

Furlong set out to redisplay the collection.[31] According to a reporter in the *Irish Times*, '[Furlong] had several objects in view; to have every picture on a level with the eye; and to have each picture isolated … Dr Furlong told me that all the modern galleries are hung in that uncrowded way'.[32]

On his return from Germany, in May 1937, Beckett was shocked with the changes. As planned, Furlong had placed the Dutch pictures in the print room, now painted 'a public lavatory green'.[33] Beckett's explains to MacGreevy: 'There is no top light & the pictures, all boldly hung in a simple line, are worse than invisible … No matter how one addresses oneself to a picture one has the light in one's eyes. And they are all hung on about a level with the pubic bone' (so much for Furlong's 'eye level').[34] In fact, he was not against single line hanging *per se* and had admired it in the Hamburger Kunsthalle just the year before.[35]

In the same letter of May 1937, Beckett criticises the new display in the upper galleries of the Dargan Wing, and his description is matched by contemporary photographs held in the Gallery's Archive (fig. 6):

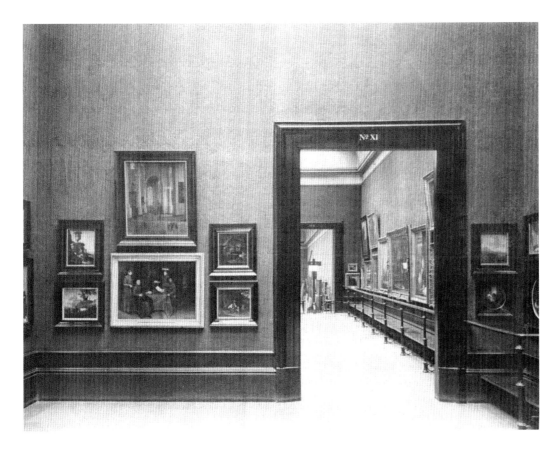

Fig. 7: Cabinet gallery in the 1864 wing, c. 1935, showing the ter Borch, National Gallery of Ireland Archive

Fig. 8: Gerard ter Borch, *Four Franciscan Monks*, c. 1647-48, oil on canvas, 72 x 97 cm, National Gallery of Ireland

The mania for single line hanging, which is all very well when there is plenty of room & the line set at the right height, is carried on upstairs, where the Italian pictures begin now in the Dutch rooms (& Irish room) & finish with the awful Gentileschi & Piazzetta in the big room where they all were previously. The wall paper has been done up an indescribable shade of anchovy which Furlong asserts 'goes well' with 'Italian pictures', as a man might have a prejudice in favour of stout with oysters. It has a pleasant effect on the blues of Canaletto & Bellotto. The result of the single line is [erasure] acres of this heavy angry colour weighing down on the pictures and on the spectator. The rail he has removed altogether. Icons of Rosalba correspond across the stairs … Now he wants artificial lighting and evening opening. It is time someone put him in mind of the purpose of a picture gallery, to provide pictures worth looking at and the possibility of seeing them.[36]

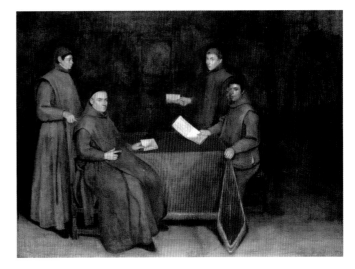

Just a few months later, Beckett is still on the attack. He dismisses the new Castiglione, *The Shepherdess Spako with the Infant Cyrus*, as 'ugly'.[37] He wishes he could spend a few hours with MacGreevy in the Italian rooms – 'You would get a shock there' – while he laments that his preferred Dutch pictures are now 'to all intents & purposes lost to the Gallery'.[38] He was undoubtedly unfair in some of his criticism of Furlong. Some of the new acquisitions may not have been to Beckett's taste, but Furlong made some very valuable additions to the collection and today works like the Gentileschi *David and Goliath* and the Castiglione count among the highlights of the Italian school.

In October 1937, Beckett moved to France and Paris was to become his permanent home for the next fifty-two years. He visited Dublin from time to time, to see his family and to catch up with old friends, including MacGreevy who was now living in Ireland, having returned during the war. Beckett refers briefly to the Gallery in a few late letters to MacGreevy dating to the early 1960s, and he also mentions it a couple of times while writing from Dublin to Georges Duthuit. In 1950, he wrote: 'I just spent an hour revisiting the National Gallery with McGreevy [*sic*]. Saw a couple of old friends again, from the time when I thought I loved painting'.[39] Of course Beckett never ceased to look at paintings with a passionate interest, but by this time, he was wary of the intuitive responses we find in his earlier correspondence. As Lois Oppenheim and Rémi Labrusse discuss in this volume, his essays on art criticism led him to mistrust any attempt to transcribe the visual experience before a work of art.

As we have seen with the Perugino, sometimes individual paintings from the Gallery's collection found their way into Beckett's early writing. More often, though, the 'memory' of a painting seen in Dublin (or in one of the many galleries he visited abroad) embedded itself in Beckett's subconscious, and tantalisingly made its way to the surface, often decades later, in his writing or stage direction. Two examples are mentioned here. In a letter of May 1935 he told MacGreevy that he found it 'worth

making the long journey to the south area pictures only to peer at the little Terborch, which no doubt is not one…'.[40] A contemporary photograph (fig. 7) (of what is today room 47) shows the installation with the Terborch he was referring to, *Four Spanish Monks* (fig. 8).[41] It is not a typical work by the artist and Beckett was wrong to doubt the attribution in this instance. Of more interest here, though, is the suggestion that this strange composition may have come into Beckett's mind almost fifty years later when staging *Ohio Impromptu*.[42]

Another painting that he certainly knew (although we have no reference to it in his correspondence) was Silvestro dei'Gherarducci's *Assumption of St Mary Magdalene* (fig. 9), which, again from contemporary photographs, we know was hanging in the upper Dargan Wing (fig. 2).[43] This powerful image of the Magdalene was surely a prompt for May's stance in *Footfalls*, the tattered nightwear of the latter retaining something of the texture of the saint's ankle-length hair (fig.10).[44]

Beckett and Jack Yeats

Beckett first visited Jack Yeats, the painter and writer, in November 1930, following a letter of introduction from Tom MacGreevy. Their meeting, their subsequent friendship, and the artistic affinities between the two men have been written about and analysed elsewhere (in this volume, see the essays by Susan Schreibman, Nicholas Allen and David Lloyd) and we need only make a few comments here relevant to the exhibition.[45]

Throughout the 1930s, Beckett visited Yeats regularly at his studio to see his latest paintings, and often made a note of them in his correspondence to MacGreevy. In May 1935, for example, following a whole afternoon in the artist's company looking at 'some quite new pictures', he noted that *Low Tide* was 'overwhelming'.[46] Beckett also enormously enjoyed their walks together and, occasionally, time spent in the Gallery. In June 1936, when he 'ran into' Yeats in the Gallery, the artist 'explained the Poussin blue …' to him, something that had fascinated Beckett for several years.[47] In 1932 he had written of Poussin's *Lamentation* that it was 'extraordinary, I never saw such blue & purple, such lyrical colour'.[48]

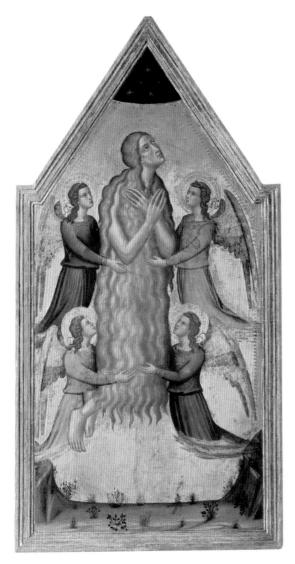

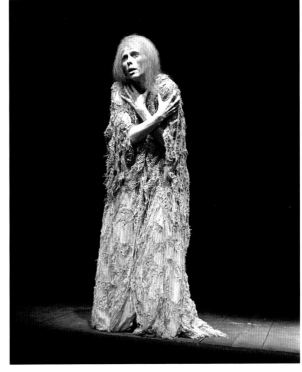

Not only did Beckett admire Yeats' work, it also stimulated his imagination, and two paintings by Yeats that have been suggested as sources for *Waiting for Godot* are included in the exhibition. The first is *Two Travellers* (fig. 28) painted in 1942 which, Knowlson suggests, Beckett could have seen in the Yeats' studio during his visit home in 1945.[49] The travellers are two tramps who stop and exchange a few words before each continues on his way, in opposite directions. The second painting is *The Graveyard Wall* (fig. 11), painted in 1945, which depicts two men, one bending to light his pipe by a small graveyard on a country road.[50] Knowlson, however, has expressed here and elsewhere that it is too simplistic to seek a single source of inspiration for a literary creation (and he prefers the term 'recognition').[51] There are, indeed, several paintings by

Fig. 9: Don Silvestro dei Gherarducci, *The Assumption of St Mary Magdalene*, 1380s, egg tempera and gold leaf on panel, 161 x 82 cm, National Gallery of Ireland

Fig. 10: Billie Whitelaw in *Footfalls*, 1976, photograph by John Haynes

Yeats that could be similarly pointed to as stimuli not only for *Godot*, but for other works by Beckett, so close often is the imagery that the one paints, and the other creates with words. Referring to the dialogue between Vladimir and Estragon, Marilyn Gaddis Rose has written: 'The overall effect is not unlike that of a verbal equivalent of a Yeats painting where a form resides within the deceptive display of colour and texture.'[52] She might equally have been alluding to the passage in *Molloy*, for example, when 'A' and 'C' meet (which again brings to mind the image of the *Two Travellers*): '… they did not pass each other by, but halted, face to face, as in the country, of an evening, on a deserted road, two wayfaring strangers will … They turned towards the sea which, far in the east, beyond the fields, loomed high in the waning sky, and exchanged a few words. Then each went on his way …'.[53]

According to Rose, the two men did not discuss their writing in progress, nor did they always send one another

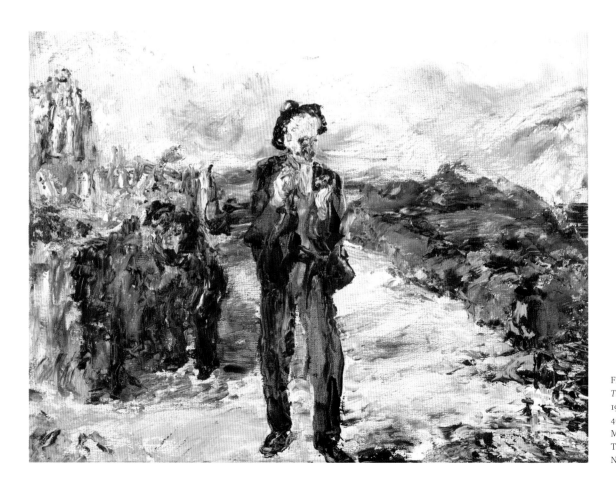

Fig. 11: Jack B. Yeats, *The Graveyard Wall*, 1945, oil on canvas, 46 x 61 cm, Sligo Municipal Collection, The Model Arts and Niland Gallery, Sligo

copies of their new publications.[54] In the Yeats archive in
the National Gallery of Ireland, however, there are three of
Beckett's books inscribed by Beckett to his friend, including
his first book *Proust*.[55]

Beckett's purchase in 1936 of *A Morning* is related
elsewhere. A prized possession, this small painting was
the one he took with him when he went into hiding during
the war: later, he gave it to the actor Jack MacGowran,
and today it is in the collection of the National Gallery of
Ireland.[56] In April 1945 he bought a second oil painting,
Regatta Evening, painted by Yeats in 1944 (fig. 12).[57]
At some stage he also acquired a small watercolour painted
in 1910, *Corner Boys*, to which he may be referring in a
letter dated 5 May 1935 when he says, 'He [Yeats] can only
recall my water colour very vaguely, as being probably
the fish market in Sligo.'[58] All three works are displayed
together in this exhibition, alongside other paintings by
Bram and Geer Van Velde, Henri Hayden and Jean-Paul
Riopelle once owned by Beckett, and these are discussed
later by Riann Coulter.

Introduction to the exhibition: part 2

Riann Coulter

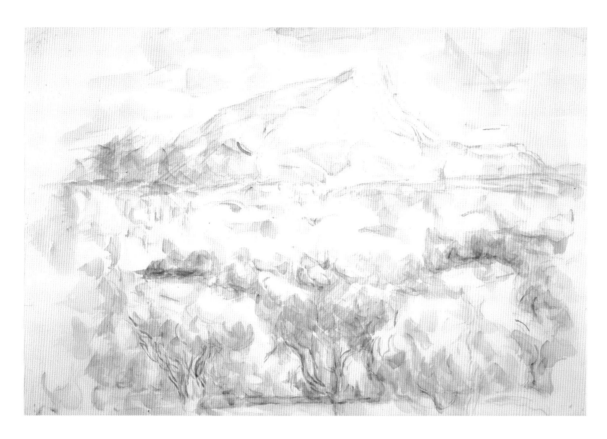

As we have seen, the origins of Samuel Beckett's passion for paintings were firmly rooted in the National Gallery of Ireland. Although his first introduction to art may have been via his artist aunt Cissie, Beckett's personal interest was weaned in the Gallery's collection and nurtured by his great friend Tom MacGreevy.[59] While Beckett developed his intimate knowledge of the Gallery throughout the 1930s and also recorded his visits to the Dublin Municipal Gallery, his hunger for art naturally drew him to the great collections throughout Europe.[60]

In London, where he moved to at the end of 1933 to undergo a course of psychoanalysis, Beckett made regular visits to the city's art galleries.[61] Often accompanied by MacGreevy, who was also living in London, Beckett immersed himself in the collections of the National Gallery, the Tate Gallery and the Victoria & Albert Museum.[62] There he found works by artists with whom he had become acquainted in Dublin, including Rembrandt, Elsheimer, Poussin and Perugino, and also made new discoveries that were to make a lasting impression.

One such artist was Paul Cézanne. In a letter to MacGreevy in 1934 describing his encounter with Cézanne's *Montagne Sainte-Victoire* (fig. 13) in the Tate, Beckett both revealed the scope of his knowledge of art history and identified elements of Cézanne's approach to landscape painting which, as Knowlson has suggested, are 'excitingly close' to the relationship between man and landscape that he would later examine through his writing:[63]

What a relief the Mont Ste. Victoire after all the anthropomorphized landscape – van Goyen, Avercamp, the Ruysdaels, Hobbema, even Claude. … Cézanne seems to have been the first to see landscape and state it as material of a strictly peculiar order, incommensurable with all human expressions whatsoever.[64]

A week later Beckett continued his analysis of Cézanne, recognising in his art an acknowledgement of the inadequacy of artistic expression that was to become the central theme of his own work:

What I feel in Cézanne is precisely the absence of rapport that was all right for Rosa or Ruysdael for whom the animising mode was valid, but would have been fake for him, because he had the sense of his incommensurability not only with life of such a different order as landscape, but even with life of his own order, even with the life … operative in himself.[65]

With their astute analysis of Cézanne's work and wide-ranging references to European art, these passages suggest the work of an art historian rather than a writer. In fact, Beckett had made a systematic study of European art history, both at first hand and through texts such as R.H. Wilenski's *An Introduction to Dutch Art*, which MacGreevy had recommended to him.[66] While the idea of Beckett as art historian may seem rather far fetched, especially in light of the radical contemporary art that has drawn inspiration from his work, in 1933 he did seriously entertain the idea of a museum career when he applied for a job in the National Gallery, London. In a letter to MacGreevy dated October 1933 Beckett wrote:

In a moment of gush I applied for a job of assistant at the National Gallery, Trafalgar Square, and got Charles Prentice and Jack Yeats to act as referees. I think I'd be happy there for a time among the pigeons … Apart from my conoysership [sic] that can just separate Uccello from a handsaw, I could cork the post as well as another … But it won't come off and I don't expect it to.[67]

Although Beckett's predictions were correct, it was arguably his continued pursuit of art historical knowledge that led him to embark on a tour of Germany in 1936–37.[68]

Germany 1936–37
Leaving Ireland in September 1936, Beckett's first stop was Hamburg, where he revelled in the Dutch and Flemish collections in the Kunsthalle and also met a surprising number of artists, collectors and art historians.[69] The German diaries discovered after Beckett's death, art notebooks that he kept during his trip, and the letters that he sent to MacGreevy from Germany all reveal the extent

of his engagement with both the Old Masters in museum collections and modern German art. These sources also suggest that art was indeed the primary focus of Beckett's German tour. While we know that Beckett had studied the Old Masters in Dublin and London, as James Knowlson reveals in his essay in this volume, by 1936 Beckett had already been introduced to modern German art by his uncle, the Kassel-based art dealer William Sinclair.[70] It was therefore as an informed and serious student that Beckett toured the German galleries.

In each of the stops on his tour, which included Hamburg, Berlin, Dresden and Munich, Beckett not only visited galleries, but also met artists and art historians, viewed private collections and encountered the increasing censorship resulting from the Nazis' categorisation of much modern art as 'degenerate'.[71] The largest *Entartete Kunst*, or Degenerate Art Exhibition, was held in Munich in July 1937, yet throughout his trip Beckett visited art collections where modern works, particularly those by Expressionists, had either been annexed or removed entirely. Although the modern works in the Hamburger Kunsthalle had been separated from the main collection and stored in the cellar, with the help of the art historian Dr. Rosa Schapire, Beckett gained access to them.[72] It was there that he studied paintings by Expressionists, including Kirchner, Nolde, Marc and Munch that arguably made an impact on his visual imagination.[73]

Although it is not the rationale of this exhibition to attempt the ultimately futile task of identifying direct sources for Beckett's imagery in particular works of art, he did identify one painting he saw in Germany – Caspar David Friedrich's *Two Men Contemplating the Moon* (fig. 14) – as a source for *Waiting for Godot*.[74] Similarly, as Knowlson examines further, some of the Expressionist works that Beckett saw in Germany may have influenced his visual imagery. While the dramatic gestures and strong contrasts of light and dark associated with the Expressionists, as well as their fascination with hysteria, angst and madness, have parallels in Beckett's work, more specific references have been identified, particularly in the work of the Norwegian Expressionist Edvard Munch.[75] Echoes of the haunting, isolated figures that Beckett admired in Munch's work[76]

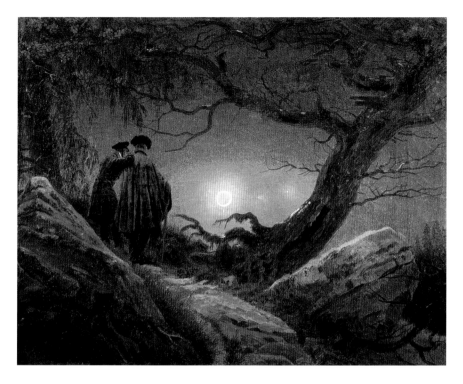

Fig. 14: Caspar David
Friedrich, *Two Men
Contemplating the
Moon*, 1819/20,
oil on canvas,
34.9 x 44.1 cm,
Gemäldegalerie Neue
Meister, Staatliche
Kunstsammlungen,
Dresden

can be found throughout his writing, but as both
Knowlson and Jessica Prinz have pointed out, it is with
Munch's iconic image *The Scream*, that the most obvious
comparisons can be made, particularly in relation to the
imagery in *Not I* and *Footfalls*.[77]

While Beckett noted his reactions to Expressionism,
he also recorded his impressions of those contemporary
artists to whom he was introduced. In his study of Beckett's
German diaries, Mark Nixon has suggested that of all the
painters Beckett met in Germany, Karl Ballmer had the
'most profound impact on his thinking'.[78] Visiting Ballmer's
Hamburg studio in November 1936, Beckett admired
the striking image *Kopf in Rot* (fig. 39), which he praised
for being neither abstract nor purely representational.[79]
As Nixon has suggested, Beckett recognised in Ballmer
the 'incommensurability' between landscape and subject
that he had celebrated in the work of both Cézanne and
Jack Yeats.[80] In an attempt to move beyond appearances
and to express the 'essence' of objects, Ballmer reduced
his pictorial content to primary forms that, by constantly
threatening to merge with the background, hover on
the threshold of vision. It was this tension between
representation and abstraction – presence and absence

– that became the central theme of both Beckett's art
criticism and arguably his whole approach to visual art.

Beckett's study of art history coincided with his
increasingly ambitious project to transform writing.
It was also during this period that he began to produce
art criticism.[81] Although he later denounced his art
criticism, in these short texts, written mainly between 1945
and 1954, he fought a battle with language that eventually
allowed him to transform modern literature.[82]

Art criticism

Beckett's forays into art criticism are discussed in this
volume by both Lois Oppenheim and Rémi Labrusse.
As both scholars stress, Beckett distrusted the very act
of criticism. Yet, despite his reservations, his texts have
been surprisingly influential. While Beckett's 'Hommage
à Jack B. Yeats', published in Paris in 1954, helped to
draw international attention to Yeats' work, it is perhaps
Beckett's writing on Bram van Velde that has become
his most lasting contribution to art history.[83]

Beckett met the Dutch brothers Bram and Geer van
Velde in Paris in 1937, but it was in the post-war period that
he became close to Bram and began to champion their art.

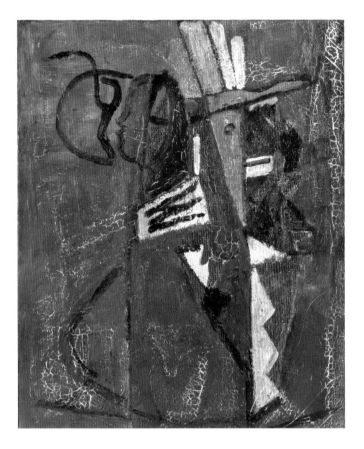

Fig. 15: Bram van Velde, *Untitled*, 1937, oil on canvas, 100.2 x 81.2 cm, Centre National d'Art Contemporain Georges Pompidou, Paris

It was probably also at this time that Beckett acquired the three works by the van Veldes included in this exhibition (figs 15 and 41).

In 1946, Beckett was commissioned by the journal *Cahiers d'art* to write a text on the van Veldes to coincide with Bram's solo show at Galerie Mai.[84] Entitled 'La Peinture des van Velde ou le Monde et le Pantalon',[85] Beckett's text begins by denouncing art criticism on the grounds that words are not capable of elucidating visual art.[86] Despite the inevitability of failure, he continues to write of Bram's paintings, describing them as being held in suspense. This is the state of suspension between representation and abstraction, presence and absence, that Beckett had admired in Ballmer's work.

In a later essay, 'Painters of Failure',[87] Beckett again stressed this sense of suspension or incompleteness in Bram's painting, writing of the 'endless unveiling … an unveiling towards the unveilable, the nothing'.[88] As David Lloyd points out here, in 1937 Beckett described his struggle with language in similar terms when he wrote 'more and more my own language appears to me like a veil that must be torn apart to get at the things (or the Nothingness) behind it'.[89]

Undoubtedly Beckett used his art criticism as an opportunity to explore his own ideas about art.[90] In fact, Peggy Phelan has suggested that Beckett's 'Three Dialogues'[91] was part of his effort to learn to write dramatic dialogue.[92] Arguing that this debate between Beckett and the art historian Georges Duthuit on the work of Tal Coat, Masson and Bram van Velde enacts rather than merely describes the critical argument, Phelan suggests that 'this sense of writing as action had enormous implications for Beckett's subsequent work, especially as he moved from prose to drama'.[93]

While the significance of Beckett's art criticism as a crucible in which he could forge his aesthetic ideas should not be underestimated, it is also important to remember that the subjects of his art writing were often close friends. Bram and Geer van Velde, Jack Yeats and Henri Hayden were all artists whom Beckett wrote about, owned works by, and counted among his personal friends.

Beckett's own collection

In this exhibition many of the art works that Samuel Beckett owned can be seen in public for the first time. Although the litany of artists that Beckett referenced in his letters and art criticism – from Perugino and Cézanne to Yeats, Ballmer and the van Veldes – was a mixture of the celebrated and the unknown, the art he owned was almost exclusively the work of friends. While to the uninitiated there is little other than Beckett's acquaintance to link Jack Yeats' Irish scenes with Bram van Velde's abstractions, or Henri Hayden's serene landscapes (fig. 16) with Jean-Paul Riopelle's expressive compositions, arguably these artists shared Beckett's personal struggle towards a form of expression free from the tyranny of representation.

In his increasingly reductive texts, Beckett sought to overcome the dependence of language on metaphor. Pursuing an analogous end, the contemporary artists whom he admired were embroiled within the debate between figuration and abstraction that dominated twentieth-century art. Just as he, even in his most minimal texts, retained a human element, so they seldom strayed into pure abstraction, preferring instead to maintain the tension between the figure and the void. In individual ways, each of the artists whom Beckett patronised shared the quest towards 'the beyonds of vision' that he had celebrated in the work of Jack Yeats.[94]

Artistic affinities

Aside from those represented in his own collection, there were other artists in Paris with whom Beckett had artistic affinities. Many of those artists, including Joan Mitchell, Alberto Giacometti and Louis le Brocquy were also befriended by Beckett, and Giacometti even collaborated with the writer.

There are several accounts of the evenings that Beckett and Giacometti spent roaming the streets of Paris together, and their relationship was certainly based as much on friendship as artistic vision. While he did not own any of Giacometti's work, Beckett did give a sketch by the artist to the director Alan Schneider, and with Beckett's help Giacometti sculpted the tree for the 1961 production of *Waiting for Godot* at the Odéon Théâtre de France, Paris

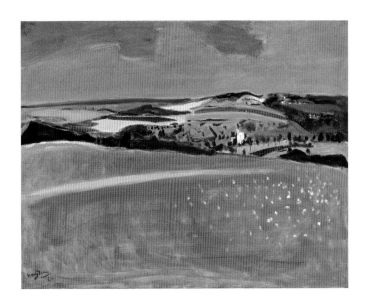

Fig. 16: Henri Hayden, *Vue sur Signy Signets*, 1962, oil on canvas, 50 x 64 cm, private collection

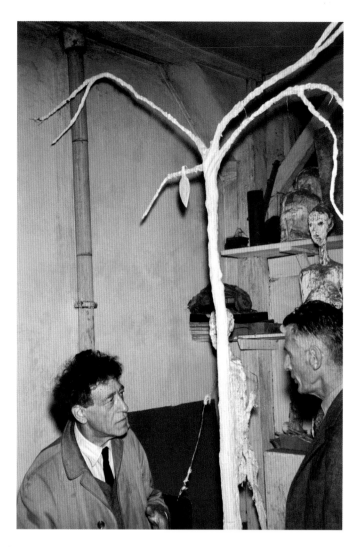

Fig. 17: Samuel Beckett in Alberto Giacometti's studio in the rue des Archives, Paris, with the tree that the sculptor designed for the 1961 Paris revival of *Waiting for Godot*. Courtesy Laurence Pierre-de Geyer

(fig. 17).[95] Although Giacometti's original tree is now lost, in 2004 the Irish artist Gerard Byrne recreated the tree as part of his installation *In Repertory*, and it is Byrne's reconstruction of Giacometti's tree that is included in this exhibition.

Aside from their friendship and collaboration, Giacometti and Beckett also had a remarkably similar approach to art. Suggesting that 'over and above the concerns Alberto Giacometti and Beckett shared with other artists of their time, beyond their personal relationship and even their professional collaboration, the bond between them lies in a similarity of creative process', Oppenheim has argued that they both believed in the impossibility of expression through art.[96] The tropes of 'reduction, negation, cancellation and despair' associated with Beckett's work are also the themes of Giacometti's oeuvre, and they shared a preoccupation with the existential void.[97]

As Sarah Wilson has examined, the post-war Parisian art world was dominated by a climate of existentialism.[98] Admiring his struggle to find adequate means of representing perceived reality, Jean-Paul Sartre championed Giacometti as an existentialist hero who conveyed the 'real nature of man's fragile and ephemeral existence'.[99] Although Giacometti rejected such readings of his work, within a post-war context it is difficult not to interpret his emaciated figures, including *L'Homme qui Marche* (fig. 18), as symbols of human despair and suffering, themes that were also central to Beckett's writing.[100] It is in both Giacometti's figurative sculptures and his frenetically reworked paintings and drawings – images that hover on the brink of vision, constantly threatening to unravel – that the visual equivalent of Beckett's writing can be found.

Although the Irish artist Louis le Brocquy did not meet Beckett until the late 1970s, the paintings in his ghostly *Presence* series (fig. 19), reminiscent of Giacometti's sculptures, also have analogies with Beckett's writing.[101] Created in an existential artistic milieu in post-war London, le Brocquy's figures, like van Velde's compositions, exist in a taut state of suspension between presence and absence. Le Brocquy was one of the few young Irish artists whom Beckett befriended and in 1989, they collaborated on

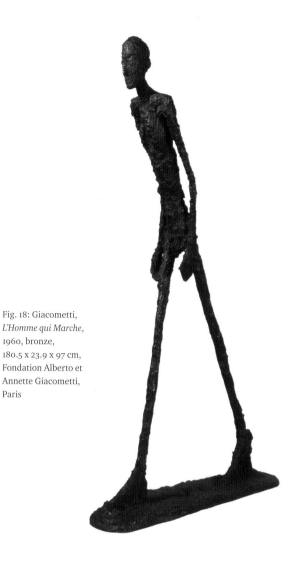

Fig. 18: Giacometti,
L'Homme qui Marche,
1960, bronze,
180.5 x 23.9 x 97 cm,
Fondation Alberto et
Annette Giacometti,
Paris

Fig. 19: Louis le Brocquy,
Ecce Homo, 1958,
oil and river sand
on canvas, 115 x 80 cm,
AR03, private collection

the *livre d'artiste* – or artist's book – in which le Brocquy
created images in response to Beckett's text *Stirrings Still*.

Livres d'artiste

While Giacometti's art is arguably analogous to his writing,
Beckett can also be considered as a visual artist in his own
right. The importance that the visual image held for him
is demonstrated by his insistence that productions of his
plays did not deviate from his precise stage directions. As
his American publisher, Barney Rossett, has commented,
'in Beckett's plays, set, the movements of the actors, the
silences specified in the text, the lighting and the costumes
are as important as the words spoken by the actors'.[102]
For Beckett, the role of dramatist went far beyond
the printed text. In some ways he was more akin to

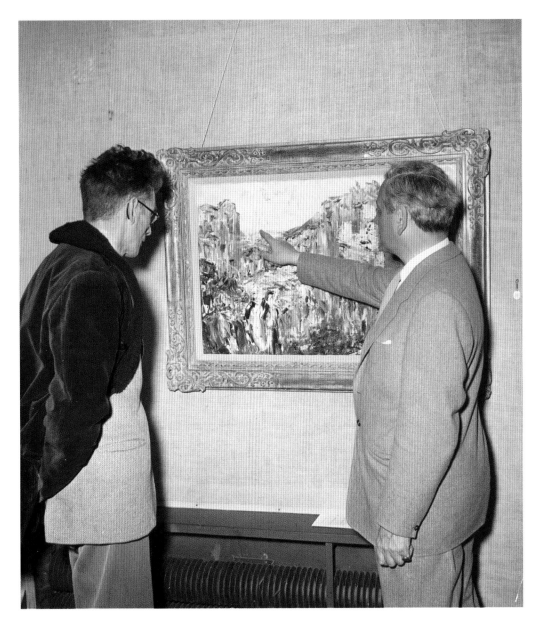

Fig. 20: Samuel Beckett and Victor Waddington looking at Jack B. Yeats', *The Music*, 1946 (oil on canvas, 61 x 91.5 cm, private collection). Probably taken at the Galerie Beaux-Arts, Paris in 1954. National Gallery of Ireland Archive

contemporary installation artists who utilise space, time, sound, image and text to create experiential works of art.

Despite his resistance to deviations from his texts, there was one field where Beckett not only permitted interpretation, but appears to have revelled in it. The *livre d'artiste* is both the descendant of the illuminated manuscripts so significant in early Irish art history, and a vital contemporary art form that has attracted many of the greatest modern artists.[103] As Breon Mitchell points out in this volume, of all the twentieth-century writers whose work has been the subject of such art works, Beckett has been the most popular. It is in these books, which create a dialogue between word and image that surpasses any simple notion of illustration, that some of the most innovative responses to Beckett's work can be found.

Each of the artist books included in this exhibition was approved by Beckett, and in this volume both Dellas Henke and Charles Klabunde recall his interest in and enthusiasm for their work. While he rigorously defended his artistic vision on stage, Beckett appears to have recognised in these artist's books the integrity and expressive freedom that he sought through his own work.

Looking forward

Considering the relationships between visual art and Beckett's writing, Phelan has argued that he 'dramatized the rhythm of looking'.[104] This emphasis on the act of 'looking' is evident not only in Beckett's comments on art, but also in his encounters with paintings. Avigdor Arikha recalls how the writer would spend hours in front of a painting, just looking and learning, and Beckett's capacity for attention is also evident in the photograph of him and the art dealer Victor Waddington looking at Yeats' painting *The Music* (fig. 20).[105] In 1945, Beckett wrote of Yeats:

> it is difficult to formulate what it is one likes in Mr Yeats's painting, or indeed what it is one likes in anything, but it is a labour, not easily lost, and a relationship once started not likely to fail, between such a knower and such an unknown.[106]

Beckett's comments on Yeats echo the rationale behind this exhibition. Although it is difficult to formulate the impact that visual art had on Beckett's work, it is through the labour of trying that new avenues of investigation are opened and previously obscure references illuminated. Thus, this exhibition is by no means the last word on Samuel Beckett's passion for paintings, but rather a platform for further exploration of the affinities, influences and echoes of visual art that contributed to the great collage of Beckett's oeuvre.

1 James Knowlson, *Damned to Fame. The life of Samuel Beckett* (Bloomsbury, London, 1996). There are references throughout to the Gallery, but see p. 57. The Gallery reopened after almost two years in February 1924, see Peter Somerville-Large, *The Story of the National Gallery of Ireland* (NGI, Dublin, 2004) p. 300

2 Knowlson 1996, p. 142, relates how Beckett in 1989 could still recall his father's pride as he accompanied his son through the little gate into Trinity that be opened using a key held only by staff.

3 Letter from Samuel Beckett to Thomas MacGreevy, 17 July 1936, TCD MS 10402. In 1936, the Gallery had 39,336 visitors. One wonders how Beckett would have coped with today's attendance of over 700,000.

4 He was right to question the attributions of the 'Velazquez' (Letter from Samuel Beckett to Thomas MacGreevy, (27) August 1932, TCD MS 10402) now catalogued as Italian School (NGI 221), and the *St George* then attributed to Paris Bordone (Letter from Samuel Beckett to Thomas MacGreevy, 14 August 1937, TCD MS 10402) and now given to Pietro degli Ingannati (NGI 779).

5 See Susan Schreibman's essay in this volume on Samuel Beckett and Thomas MacGreevy

6 Knowlson 1996, p. 235

7 Letter from Samuel Beckett to Thomas MacGreevy, 9 October 1933, TCD MS 10402. There is no record of this application in the National Gallery, London archives.

8 Thomas Bodkin purchased Perugino's *Pietà* (NGI 942) in June 1931, and considered it, at £3,990, to be his 'greatest bargain': see Somerville-Large 2004, p. 322. A private unveiling reception took place in the Gallery on 28 November 1931: see Anne Kelly, 'Thomas Bodkin at the National Gallery of Ireland', *Irish Arts Review Yearbook* (1991/92), p. 176

9 Letter from Samuel Beckett to Thomas MacGreevy, 20 December 1931, TCD MS 10402

10 National Gallery of Ireland Archive

11 Letter from Samuel Beckett to Thomas MacGreevy, 14 May 1937, TCD MS 10402

12 Letter from Samuel Beckett to Thomas MacGreevy, 14 August 1937, TCD MS 10402

13 'Love and Lethe' was written in early 1933.

14 Samuel Beckett, *More Pricks than Kicks* (John Calder, London, 1993), p. 93; this reference (and the following to The Master of Tired Eyes) are cited in Eoin O'Brien, *The Beckett Country* (The Black Cat Press, Dublin in association with Faber and Faber, London, 1986), p. 140

15 Beckett, *More Pricks than Kicks,* 1993, p. 93

16 According to Avigdor Arikha, Beckett could spend up to an hour in front of a single painting. See Knowlson 1996, p. 195

17 These were collated by O'Brien 1986, see p. 138 *ff.*

18 NGI 903: today it is Flemish School, c.1540

19 Letter from Samuel Beckett to Thomas MacGreevy, 13 September 1932, TCD MS 10402. The 'German' room he refers to is today Room 43: until 1996 there was a staircase connecting it with Room 46 in the upper Dargan Wing.

20 Beckett, *More Pricks than Kicks,* 1993, p. 47

21 NGI 603

22 Beckett, *More Pricks than Kicks,* 1993, p. 67

23 NGI 827. My thanks to Sergio Benedetti for this suggestion.

24 Letter from Samuel Beckett to Thomas MacGreevy, 15 May 1935, TCD MS 10402. According to Arnold, Jack Yeats was discreetly advising Beckett to encourage MacGreevy to apply: see Bruce Arnold, *Jack Yeats* (Yale University Press, New Haven and London, 1998), p. 269

25 Letter from Samuel Beckett to Thomas MacGreevy, 7 May 1936, TCD MS 10402

26 This is *David and Goliath*, NGI 980. Letters from Samuel Beckett to Thomas MacGreevy, 9 June 1936 and 27 June 1936, TCD MS 10402

27 Letter from Samuel Beckett to Thomas MacGreevy, 17 July 1936, TCD MS 10402. The Bazzanis are NGI 982 and 983; the Lys is NGI 981, now catalogued as After Jan Lys.

28 *Le Corsage Noir* (NGI 984) was purchased in June 1936. In August, Beckett wrote: 'They have a very good new Morisot … very refreshing after Bazzani, Gentileschi & Co. Very Joycesque'. Letter from Samuel Beckett to Thomas MacGreevy, 19 August 1936, TCD MS 10402

29 NGI 978

30 Letter from Samuel Beckett to Thomas MacGreevy, 26 July 1936, TCD MS 10402

31 See Somerville-Large 2004, p. 333

32 *Irish Times*, 21 March 1936

33 He is probably referring to Room 23, on the mezzanine level of the Dargan Wing, which today houses the National Portrait collection.

34 Letter from Samuel Beckett to Thomas MacGreevy, 14 May 1937, TCD MS 10402

35 Letter from Samuel Beckett to Thomas MacGreevy, 9 October 1936, TCD MS 10402

36 Letter from Samuel Beckett to Thomas MacGreevy, 14 May 1937, TCD MS 10402

37 NGI 994

38 Letter from Samuel Beckett to Thomas MacGreevy, 14 August 1937, TCD MS 10402

39 Letter from Beckett to Georges Duthuit dated Dublin, Monday, (1950?), Duthuit Archives, Paris: "Viens de passer une heure à revisiter la National Gallery avec McGreevy. Revu quelques anciens amis, du temps où je croyais aimer la peinture". See also Rémi Labrusse's round table presentation in this volume.

40 Letter from Samuel Beckett to Thomas MacGreevy, 15 May 1935, TCD MS 10402

41 NGI 849

42 Anne Atik, How it Was. A memoir of Samuel Beckett (Faber and Faber, London, 2001), p. 6

43 NGI 841

44 Antonello da Messina's Virgin of the Annunciation in the Alte Pinakothek, Munich, has also been considered to be a prototype for May's pose. See Knowlson in John Haynes and James Knowlson, Images of Beckett (Cambridge University Press, Cambridge, 2003), p. 74

45 See also references in Knowlson 1996 and Arnold 1998

46 Letter from Samuel Beckett to Thomas MacGreevy, 5 May 1935, TCD MS 10402: Low Tide was, and is, in the Municipal Gallery, now Dublin City Gallery The Hugh Lane, and is included in this exhibition.

47 Letter from Samuel Beckett to Thomas MacGreevy, 27 June 1936, TCD MS 10402

48 Letter from Samuel Beckett to Thomas MacGreevy, August 1932, TCD MS 10402

49 See Knowlson 1996, pp. 378-79. See also David Lloyd's discussion of the painting in this volume. Two Travellers belongs to the Tate Gallery, London, but is currently on long-term loan to the National Gallery of Ireland

50 Suggested by Peggy Phelan in, 'Lessons in Blindness from Samuel Beckett' in PMLA (October 2004), pp. 1280-81

51 See Knowlson 1996, p. 378, and also in this volume.

52 Marilyn Gaddis Rose, Jack B. Yeats: Painter and Poet, European University Studies (Herbert Lang, Berne and Frankfurt/M, 1972), p. 46

53 Samuel Beckett, Molloy, in Three Novels by Samuel Beckett (John Calder, London, 1959), p. 9

54 Rose 1972, p. 45. Apparently, Yeats did not admire Beckett's writing finding his outlook 'amoral': letter from Alan Denson to Anthony Piper after an interview with Yeats, 30 September 1954, cited in Hilary Pyle, Jack B. Yeats. A biography (Routledge, London, 1970), p. 146

55 Inscribed 'for Jack Yeats from Sam Beckett heepishly. 23/3/31'

56 The Gallery acquired A Morning (NGI 4628) in 1997.

57 Hilary Pyle, Jack B. Yeats. A Catalogue Raisonné of the Oil Paintings (Andre Deutsch, London, 1992), vol. 2, p. 596, no. 652

58 Letter from Samuel Beckett to Thomas MacGreevy, 5 May 1935, TCD MS 10402: however, Corner Boys was exhibited in the National College of Art in 1945, which would seem to imply that Beckett only acquired it after that date on one of his post-war visits to Dublin. See Hilary Pyle, Jack B. Yeats. His Watercolours, Drawings and Pastels (Irish Academic Press, Dublin, 1993), p. 165, no. 701

59 Cissie (Frances) Beckett attended The Dublin Metropolitan School of Art where she was a contemporary of Estella Solomons and Beatrice and Dorothy Elvery. The Elvery family were the Becketts' neighbours and as a child Samuel Beckett posed for a photograph which Dorothy Elvery used as the basis of her paintings Child at Prayer and possibly also Twins. Dorothy Kay (née Elvery), The Elvery Family: A Memory, Memoirs of the Artist Dorothy Kay (ed. Marjorie Reynolds) (The Carrefour Press, Cape Town 1991), pp. 37, 41

60 In a letter to MacGreevy dated 25 July 1933, Beckett mentions a visit to the Municipal Gallery in Charlemont House where he remarks on the absence of Lurçat's Decorative Landscape, included in this exhibition. Letter from Samuel Beckett to Thomas MacGreevy, 25 July 1933, TCD MS 10402

61 Traumatised by the sudden death of his father in June 1933, Beckett was advised by his doctor friend, Geoffrey Thompson to undergo a course of psychoanalysis. As psychoanalysis was not available in Dublin, Beckett moved to London shortly after Christmas 1933 where he was treated by W.R. Bion at the Tavistock Clinic. Knowlson 1996, pp. 170-74

62 Knowlson 1996, p. 195. As Knowlson notes, Beckett also familiarised himself with the art in the Wallace Collection and Hampton Court. Beckett recorded lists of the paintings he saw in London in a notebook now in the Beckett Archive, University of Reading, MS 5001

63 Knowlson 1996, p. 196. The version of Montagne Sainte-Victoire included in this exhibition is from the National Gallery of Ireland collection and was presented to the Gallery, later, in 1954 (NGI 3300).

64 Letter from Samuel Beckett to Thomas MacGreevy, 8 September 1934, TCD MS 10402

65 Letter from Samuel Beckett to Thomas MacGreevy, undated [16 September 1934] TCD MS 10402, quoted in Knowlson 1996, pp. 196-97

66 Writing to MacGreevy in October 1932, Beckett asked him to recommend 'an informative book on Dutch painting'. Letter from Samuel Beckett to Thomas MacGreevy, 8 October 1932, TCD MS 10402. Beckett took notes from Wilenski which are in the same notebook that included lists of paintings from London Collections. Beckett Archive, Reading University, MS 5001

67 Letter from Samuel Beckett to Thomas MacGreevy, 9 October 1933, TCD MS 10402

68 Knowlson 1996, p. 243, has suggested that Beckett had come to Germany in order to embark on 'an extended tour of its major galleries and art collections, so that he could look at leisure at the pictures that he had always wanted to see and extend his range into areas on which he was not already an expert'.

69 For an account of Beckett's time in Hamburg see Knowlson 1996, chapter 10; Matthias Mühlung, Mit Samuel Beckett in der Hamburger Kunsthalle (Hamburg, 2002) and Mark Nixon's unpublished Ph.D. diss., 'What a tourist I must have been': The German Diaries of Samuel Beckett (University of Reading, 2005).

70 As Knowlson discusses in his essay in this volume, between 1928 and 1932 Beckett visited William and Cissie Sinclair in Kassel several times.

71 As Nixon points out, as early as April 1933 the Nazis had already begun to remove decadent or 'degenerate' art from public collections and also to 'cleanse' the museums and art colleges of artists and art historians who were considered 'modern' or racially 'impure'. Nixon 2005, p. 145

72 A special pass was required to access the works in the cellar of the Hamburger Kunsthalle and it was Schapire who arranged such a pass for Beckett. Thanks to Mark Nixon for this information.

73 Knowlson 1996, p. 235. See also Mühling 2002

74 Beckett saw this painting in Dresden in 1937. *German Diaries*, vol. 5, 14 February 1937, quoted in Knowlson 1996, p. 254. Knowlson notes that Beckett referred to Friedrich in his notebook for the Berlin production of *Godot* in 1975 and also noted 'Kaspar David Friedrich's Men and Moon', in a manuscript notebook of *Watt* written in 1943. In 1975, Beckett told Ruby Cohn that Friedrich's painting *Man and Woman Observing the Moon* was the source for *Godot*. As Knowlson suggests, it is likely that Beckett either confused these very similar works, or was inspired by both pictures. Knowlson 1996, pp. 378 and 777.

75 For a further discussion of the influence of Expressionist techniques on Beckett's stage imagery, see Knowlson in Haynes and Knowlson 2003.

76 Beckett noted his admiration for Munch's painting *Three Women on a Bridge*: *German Diaries*, 22 November 1936, quoted by Nixon 2005, p. 151

77 See Knowlson's essay in this volume and Jessica Prinz, 'Resonant Images: Beckett and German Expressionism', *Samuel Beckett and the Arts: Music, Visual Arts, and Non-Print Media* (ed. Lois Oppenheim) (Garland Publishing, New York and London 1999). Although there is no record of Beckett seeing *The Scream* first hand, considering his early interest in Munch's work it is reasonable to assume that, by 1972 when *Not I* was written, he was familiar with this much reproduced work.

78 Nixon 2005, p. 164

79 Samuel Beckett, *German Diaries*, vol. 2, 26 November 1936, quoted by Knowlson 1996, p. 240. Knowlson discusses Ballmer further in his essay in this volume.

80 Nixon 2005, p. 165

81 Beckett's earliest published art criticism was probably the paragraph he wrote on Geer van Velde for the 1938 exhibition of his work at Peggy Guggenheim's London Gallery.

82 See Rémi Labrusse's contribution in the proceedings of 'Beckett and the Visual Arts: A Round Table Discussion', reproduced in this volume.

83 As Frances Morris has pointed out, Beckett's writings have continued to cast a shadow over subsequent interpretations of Bram van Velde's work. 'Bram van Velde', *Paris Post War: Art and Existentialism 1945-55*, exh.cat. (ed. Frances Morris) (Tate Gallery, London, 1993), p. 171

84 Although this article was Beckett's first published text on Bram van Velde's work, their correspondence suggests a deep mutual sympathy already existed in 1940. Morris, 'Bram van Velde', in Morris (ed.) 1993, p. 171

85 'The Painting of the van Veldes or the World and the Pair of Trousers'. As Knowlson notes, the reference to the world and the pair of trousers alludes to the story of a tailor who takes many weeks to make a pair of trousers for a customer. When the client objects that it took God only seven days to make the world, the tailor replies, 'look at the world and look at my trousers!', Knowlson 1996, p. 357.

86 *ibid.*

87 Published in French as 'Peintres de l'Empêchement' in *Derrière le Miroir*, June 1948, Beckett's English translation of this text was published the same year as 'The New Object', in the exhibition catalogue, *Geer and Bram van Velde*, Samuel M. Kootz Gallery, New York.

88 Samuel Beckett, 'The New Object', in *Geer and Bram van Velde*, exh. cat. (Samuel M Kootz Gallery, New York, 1948) unpag., quoted by Morris (ed.) 1993, pp. 171-72

89 Samuel Beckett, Letter to Axel Kaun, 9 July 1937, reprinted in *Disjecta: Miscellaneous Writings and a Dramatic Fragment* (ed. R. Cohn) (Grove Press, New York, 1984), pp. 170-71

90 Samuel Beckett, 'The New Object', 1948, quoted in Morris (ed.) 1993, p. 171

91 Samuel Beckett, 'Three Dialogues with Georges Duthuit', *transition* (1949) reprinted in *Disjecta*, pp. 138-45

92 Phelan 2004, p. 1283

93 *ibid.*

94 Samuel Beckett, 'Homage to Jack B. Yeats', *Disjecta*, p. 149

95 Letter from Alan Schneider to Samuel Beckett 4 January 1965 reproduced in *No Author Better Served: The Correspondence of Samuel Beckett & Alan Schneider* (ed. Maurice Harmon) (Harvard University Press, Cambridge Mass. and London, 1998), p. 181. Although Harmon identifies the sketch as 'a full-length drawing of SB, untitled', inquiries with Schneider's family suggest that the sketch was of a walking female figure in profile. Thanks to Lois Overbeck and Lois Oppenheim for their help in clarifying this point.

96 Lois Oppenheim, *The Painted Word: Samuel Beckett's Dialogue with Art* (University of Michigan Press, Ann Arbor, 2000), p. 148

97 H. Porter Abbott, *Beckett Writing Beckett* (Cornell University Press, Ithaca, 1996), p. 108, quoted in Oppenheim 2000, p. 148

98 Sarah Wilson, 'Paris Post War: In Search of the Absolute', in Morris (ed.) 1993, p. 25

99 Frances Morris, 'Alberto Giacometti', in Morris (ed.) 1993, p. 105. Sartre first championed Giacometti in 'The Search for the Absolute', 1948.

100 *ibid.* Giacometti rejected these interpretations of his work, claiming that the evocative quality of his imagery was largely unintentional. For a further discussion of the relationship between Sartre and Giacometti see Wilson 1993, in Morris (ed.) 1993, pp. 25-52

101 Le Brocquy and Giacometti met briefly at the 1956 Venice Biennale where le Brocquy, who was representing Ireland, admired Giacometti's *Venice Women* series. I examine the affinities between le Brocquy's *Presences* and Giacometti's sculpture further in *Nationalism, Regionalism & Internationalism: Cultural Identity in Irish Art 1943-60*, unpublished Ph.D diss. (Courtauld Institute of Art, University of London, 2006).

102 Barney Rossett, quoted in Enoch Brater, *Beyond Minimalism: Beckett's Late Style in the Theatre* (Oxford University Press, Oxford, 1987), p. 30

103 The Book of Kells, an illuminated manuscript of the Four Gospels dating from c.800, is housed in Trinity College Dublin where Beckett was both a student and lecturer.

104 Phelan 2004, p. 1280

105 Knowlson 1996, p. 195

106 Samuel Beckett, 'MacGreevy on Yeats', *Irish Times*, 4 August 1945, reprinted in *Disjecta*, pp. 95-97

'between us the big words were never necessary' Samuel Beckett and Thomas MacGreevy: a life in letters

Susan Schreibman

On 19 March 1927 the French Consul in Dublin asked the Board of Trinity College, Dublin if they had a candidate they wished to propose for the prestigious exchange post of *lecteur d'anglais* at the École Normale Supérieure in Paris for the 1927-28 academic year.[1] Trinity College had a candidate in mind, hand picked by T.B. Rudmose-Brown, the then Professor of French, who was grooming his star pupil, Samuel Beckett, for an academic position in his department. Beckett was expected to graduate in autumn 1927 (he, in fact, graduated with First Class Honours in Modern Languages and received a Gold Medal for outstanding scholarship). The year in Paris would provide him with the opportunity of bringing back a piece of publishable research which would eventually lead to a secure position in academia.

But Brown's plans were thwarted twice, albeit unintentionally, by the same man, Thomas MacGreevy, who was instrumental in changing the course of Beckett's life, becoming one of Beckett's few life-long confidants and close male friends. MacGreevy, born in Tarbert, Co. Kerry, was thirteen years Beckett's senior, and by 1928 a published poet and established art and literary critic. He embarked on a career in the Civil Service in 1910 at the age of sixteen, and was working in London for the Department of the Admiralty when Britain declared war on Germany. When conscription was introduced in 1916, he joined the Royal Field Artillery as a second lieutenant, and was wounded twice while serving in France. After the war, he took advantage of a scholarship for ex-officers to enrol at Trinity College, Dublin, receiving in 1920 a Second Class Honours degree in History and Political Science. After graduation, MacGreevy actively participated in the cultural and political life of the Ireland that was emerging. Like so many of his compatriots, however, he became disillusioned with the particular form of Catholicism endorsed by the State, feeling further marginalised due to his lack of Irish, coupled with his having fought with the British in France rather than against them in Ireland.

In 1925 he moved to London working as an art reviewer, and later editor for *The Connoisseur*. In January 1927 the opportunity arose to move to Paris as a replacement for William McCausland Stewart, who was the current English Reader at the École Normale. Stewart had received an offer of a lectureship at Sheffield University six months before the end of his appointment and recommended MacGreevy to the director of the École Normale Supérieure, the distinguished literary critic Gustave Lanson. Lanson interviewed MacGreevy, and accepted Stewart's recommendation with the approval of Trinity's Board.[2] Thus, shortly after New Year 1927 MacGreevy was installed in the room reserved for the *lecteur* in the heart of the Latin Quarter (fig. 21).

A few months later, the process of appointing a new Reader for the 1927-28 academic year began, but officials at the École were so pleased with his work that they, in a most unusual step, allowed MacGreevy to retain his appointment for another year and recommended that the Board might send Beckett to a provincial university instead.[3] An irate Professor Rudmose-Brown would not hear of sending Beckett to a provincial institution, and found him an appointment as teacher of French at Campbell College in Belfast. Although Beckett must have been grateful to Brown for securing him full-time employment, he was extremely uncomfortable in the role of a teacher and was relieved to be able to get away at the end of the academic year.

Early in 1928, the matter was brought up again by Trinity's Board, and this time Beckett's appointment was approved. Beckett arrived in Paris on 1 November 1928,[4] expecting to move into the rooms reserved for the English Reader and to settle into a quiet life of scholarship. When Beckett arrived he found MacGreevy still occupying the room. MacGreevy assured him he would be moving his few possessions to his new room down the hall right away, but not before the seeds were sown for one of the most important friendships of Beckett's life.

Despite the differences in their backgrounds, a bond developed between the two men that would last for the next forty years. Born into a prosperous Anglo-Irish family, Beckett was raised in Foxrock, one of the more affluent suburbs of Dublin, with many of the advantages available to a young man with his family's social standing. MacGreevy was born into a Catholic family of farmers and teachers of modest means in the west of Ireland. Although he completed all the formal schooling available to him in Tarbert by the age of fifteen, his family could not afford for

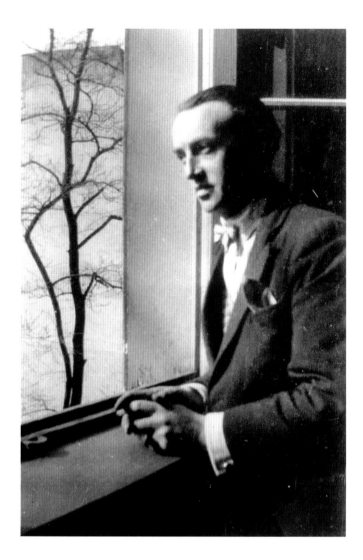

Fig. 21:
Thomas MacGreevy
at the École Normale
Supérieure, Paris,
c. 1928. Courtesy Margaret
Farrington and Robert

him to continue his education: hence the decision to join the Civil Service.

MacGreevy was a discreet extrovert, a rare combination of character traits. He was sociable, witty, a superb conversationalist with a wicked sense of humour. He was also learned, principled, and a devoted friend, often promoting the interests of others over his own. Particularly in the area of the arts, his knowledge was encyclopaedic – indeed, Beckett once described him as a 'living Encyclopedia'.[5] Those who knew him said his discretion and genuine concern for others allowed friends to open up to him freely.

According to Knowlson, Beckett was, at this time, 'almost pathologically shy'.[6] When they were out with friends, however, MacGreevy's loquacity masked some of Beckett's introversion. MacGreevy also served as an early role model and mentor for Beckett as he began to think about an alternative career to teaching.[7] Georges Belmont,[8] a student of both Beckett and MacGreevy at the École, saw MacGreevy as 'a kind of cultured and comprehensive elder brother' to Beckett.[9] But the friendship was not one-directional. Although MacGreevy had a wide circle of friends, he felt an acute absence in Paris, as he had while living in London. He was in need of someone from his own background and intellectual temper, and although at the time Beckett was 'maddeningly young',[10] MacGreevy found in him a fellow traveller.

Within weeks of Beckett's arrival in Paris, he was drawn into MacGreevy's orbit of friends and acquaintances not just in Paris, but also in London and Dublin: MacGreevy's life in the Quarter soon became Beckett's. Through some fault of MacGreevy's, Beckett was diverted from his academic work. Rudmose-Brown was thwarted a second time, and Beckett never finished that research. It was, however, not for many years that Beckett truly found his calling, and his voice.

In light of the closeness of their relationship, it is surprising how little time Beckett and MacGreevy spent living in the same place at the same time: Paris between November 1928 and September 1930, and again between January and June 1932; London from December 1933 to December 1935. Rather, they seemed to follow one another

from Paris to London to Dublin (and in MacGreevy's case, Tarbert), with extended stays in Germany, Italy, and the South of France, but never at the same time. Despite their best efforts, they never managed to take a holiday together, although Beckett's letters to MacGreevy are full of plans never realised, due, in the main, to lack of funds.

The Second World War ruptured their friendship, as it ruptured so much of Europe. Beckett's experiences, first as a member of the Resistance in Paris and then in hiding in Roussillon, a village in Vichy France, and MacGreevy's experiences in London during the Blitz and then in Dublin, set their lives down divergent paths. After the war, the intertwined threads of their lives loosened but never broke.

One month after Beckett's arrival in Paris in November 1928, he appears for the first time in MacGreevy's correspondence. MacGreevy wrote to a friend that they attended Molière's *Le Bourgeois Gentilhomme,* staying out until 4.45 the following morning at Montparnasse.[11] Both men were night owls: rarely up before noon, they preferred the late night buzz of cafes to early morning croissants and coffee. Both were desperately poor, and delaying breakfast until noon meant only one other meal was necessary later in the day. During the early 1930s, Beckett and MacGreevy seemed to have passed the same pound between them, whoever was less 'tight' loaning the other the 'miserable quid'.[12]

By the late 1920s, many of the first wave of expatriates who had made Paris their home after the First World War had dispersed. James Joyce, however, was in residence, and MacGreevy had renewed an earlier acquaintance with him soon after his arrival. Within days MacGreevy was acting as an assistant to Joyce, who had already undergone nine eye operations and needed help with the composition of *Finnegans Wake* (still known only as *Work in Progress*).[13] Shortly after Beckett's arrival, MacGreevy introduced Beckett to the 'Penman', as they referred to him, and Beckett, like MacGreevy, was soon taking dictation, looking up references and sources for *Work in Progress*, and reading to Joyce.

Joyce may have been one of the most significant of the introductions MacGreevy made for Beckett, but there were many others. There was Eugene Jolas, editor of the *avant-garde* journal *transition,* who published some of Beckett's early work; Samuel Putnam, editor of *The European Caravan*, an *Anthology of the New Spirit in European Literature*, who solicited poems and translations from Beckett; and Sylvia Beach, owner of the bookshop Shakespeare & Co, where Beckett spent many hours reading. Both men were recruited in 1929 to defend *Work in Progress* (which was being published serially in *transition*) from its critics. Beckett's first professionally-published criticism, 'Dante . . . Bruno . Vico . . Joyce' (prefiguring the breath pauses in Beckett's later drama, the number of full stops between authors' names is significant) was first published in *transition*, and then reprinted in *Our Exagmination Round his Factification for Incamination of* Work in Progress. A chance remark by MacGreevy to Beckett on the closing day of a competition for a poem on the theme of Time, brought Beckett a £10 prize and his first poetry publication in book form, *Whoroscope,* in June 1930.[14] MacGreevy also introduced Beckett to Charles Prentice, a senior editor at Chatto & Windus who had, as Richard Aldington wrote, a genius for publishing. Prentice was generous, without affectation, and considerate to the point of diffidence.[15] He became much more than an editor to Beckett, not only publishing Beckett's critical monograph *Proust* (1931) and his first collection of short stories, *More Pricks than Kicks* (1934), but a genuine friend and one of the few people Beckett made a point of calling on when passing through London.

In September 1930 Beckett reluctantly returned to Dublin to take up the post of assistant to Rudmose-Brown at Trinity College. Upon his arrival home at Cooldrinagh his clothes were confiscated (probably to be burned), and he was sent to be fitted for a bowler hat,[16] a sign of the middle class respectability he was now expected to acquire. The pressure to conform was enormous. He closed a letter to MacGreevy the following month, 'Do write again. I needn't tell you I will miss you too. And all that life in Paris that was an approximation to something reasonable'.[17] MacGreevy, understanding that Beckett

had to find ways to recreate somehow the intellectual and emotional network of Paris, urged him to visit some of his friends in Dublin whom he felt could fill the void, but Beckett, still painfully shy, found it impossible to 'inflict' himself on them.[18] MacGreevy continued to urge him, becoming, no doubt, increasingly alarmed by Beckett's letters indicating his growing isolation.[19]

MacGreevy was particularly keen that Beckett meet Jack B. Yeats. MacGreevy had been introduced to the painter in the early 1920s and soon became not simply a friend, but one of the most consistent and eloquent champions of Yeats' work.[20] In November 1930, MacGreevy wrote to Yeats advising him that Beckett might call round, succinctly summing up Beckett's pedigree, credentials, personality, and situation:

> My last years [sic] colleague and my successor Samuel Beckett is still in Dublin for a little while. He's a nice fellow the nephew of Cissie Sinclair. I told him to introduce himself to you from me if he saw you but I suppose he hasn't done so. He lives at Cooldrinagh, Foxrock. It would be a charity to ask him round one afternoon and show him a few pictures and drop all the conversational bombs you have handy without pretending anything. But the luck will be all on his side, he says very little specially at first, and you might find him not interesting, so don't do it unless you feel like doing nothing one day. Joyce does like him however and I'm genuinely fond of him tho' he's maddeningly young ...[21]

Finally, on 25 November Beckett found the courage to call on Yeats during one of his 'at homes'. It is clear from his letters to MacGreevy that he deeply admired not only the work but also the man. After that first visit, he wrote to MacGreevy, who related Beckett's impressions to Yeats:

> Beckett wrote me about his visit to you. I'm glad you liked him. He was completely staggered by the pictures and though he has met many people through me he dismissed them all in his letter in the remark "and to think I owe meeting Jack Yeats and Joyce to you!"[22]

During the years he lived in Dublin or when on a visit home after he moved permanently abroad, Beckett never failed to call on Yeats. At Yeats' studio, visitors were invited to look at Yeats' latest paintings and were served sherry with a dash of lemon while engaging in a free-wheeling discussion. Following one visit to the studio, Beckett recalled how Yeats asked him for a definition of cruelty, 'declaring that you could work back from cruelty to original sin'.[23] Sometimes, Beckett would accompany Yeats on a walk around Dublin, or when Beckett had a car at his disposal, on a drive to the country accompanied by a long walk. Yeats was as devoted a walker as Beckett, frequently being seen perambulating through the streets of Dublin.[24] Beckett relished the rare occasions he had Yeats to himself:

> Yesterday afternoon I had Jack Yeats all to myself, not even Madame [Mrs Yeats], from 3 to past 6, and saw some quite new pictures. He seems to be having a green period. ... He can only recall my water colour very vaguely, as being probably the fish market in Sligo. ... In the end we went out, down to Charlemont House to find out about Sunday opening, & then to a pub for a drink. He parted as usual with an offer to buy me a Herald. I hope to see him again before I leave, but do not expect ever to have him like that again.[25]

In January 1936 he called around to Yeats' studio to find that Yeats had painted a number of small pictures for an exhibition he was to have in London. He was taken with one entitled *A Morning*, a skyscape, as Beckett described it, with a 'wide street leading into Sligo looking west as usual, with boy on a horse'. It cost £30. Beckett desperately wanted it, but £30 was beyond his means. He wrote to MacGreevy: 'Do you think he would be amenable to instalments. It's a long time since I saw a picture I wanted so much.'[26]

The next time they met, it was Yeats who brought up the subject of the picture. Beckett borrowed £10 for the first instalment and was delighted with the painting on his wall: 'It is nice to have Morning on one's wall that is always morning and a setting out without the returning home'.[27] By August Beckett was relieved to have the painting paid

off. Some twenty years later, when MacGreevy acted as executor for Yeats' estate, he was plagued with collecting the outstanding balances of many such purchases.

One of Beckett's abiding pleasures while in Dublin was visiting the National Gallery of Ireland. It was much smaller than the present Gallery (what is referred to as the 1968 Wing was planned during MacGreevy's tenure as Director). Beckett loved the Old Masters and was keenly sensitive, not only to the paintings' composition and colours, but also to their juxtaposition in relation to each other, reaching for a visual vocabulary that would find expression in his later plays:

> I went to the Gallery yesterday and looked at the Spanish room & the Poussins. The El Greco St Francis looks very flashy when you can turn your head and see the Rubens version in the next room. The Poussin Entombment is extraordinary, I never saw such blue & purple, such lyrical colour.[28]

He wrote frequently to MacGreevy about new paintings acquired by the Gallery, knowing his friend would be keen to keep up with the collection.

When, in late 1931, Beckett decided that he could not commit to an academic life, he returned to Paris where MacGreevy was still in residence, moving into the hotel where MacGreevy had a room, the Trianon Palace, at 3 rue de Vaugirard. They had adjoining rooms for the first six months in 1932. MacGreevy captures the rhythm of their lives in one of the most lyrically evocative passages of his unpublished memoirs:

> There was a time when I dreamed of being a writer. As things worked out I never became more than a part-time writer. That could be due to economic circumstance. It could be due as well to my psychological make-up. I think I may say that I have always been as much interested in living as in writing about living. When, for a time at the École Normale in Paris and later, for a short period at the hotel in the Quarter, Samuel Beckett and I had adjoining rooms and breakfasted together, Sam could go straight from his

morning tea or coffee to his typewriter or his books, his biblical concordance, his dictionaries, his Stendhal. I, on the contrary, had to go out and make sure that the world was where I had left it the evening before.[29]

The book to which Beckett returned after their coffee was a novel, *Dream of Fair to Middling Women*,[30] which remained unpublished during his lifetime. There was also a renewed friendship with Joyce, but Beckett was forced to leave France in July as he did not have the proper residency papers.[31] He moved briefly to London, and then, almost penniless, returned to Dublin. By December 1933, he had returned to London to begin a course of psychotherapy treatments. MacGreevy had moved there the previous month, staying at the home of Hester Travers Smith in Cheyne Gardens. In September 1934 when Beckett moved to 34 Gertrude Street, they lived a few minutes walk from one another (fig. 22).

MacGreevy had met Travers Smith in Dublin, where she had been a society hostess. In London she held a literary salon, and was a medium, regularly conducting séances in her sitting room. Particularly while MacGreevy was in residence, Beckett called frequently and delighted in playing the magnificent grand piano. As in Paris, MacGreevy was Beckett's lifeline to the world. When MacGreevy returned to Tarbert at Christmas 1933, staying on due to his mother's illness for several months, Beckett wrote: 'I miss you acutely',[32] and despite MacGreevy's urgings, often felt too awkward to call at Cheyne Gardens to use the piano.

At Christmas 1935, Beckett's therapy ended and he returned to Dublin. The following September, he left for an extended tour of Germany, sailing via Le Havre, where MacGreevy had disembarked nearly twenty years earlier bound for combat on the Somme. The seven months Beckett spent in Germany were to have a profound effect on his writing. The purpose of the trip was to make a tour of the galleries of Germany, and his letters to MacGreevy during this time are filled with observations on art, the increasingly darkening political situation, news of his family, his mental and physical health, and the rounds *Murphy* was making at London publishers. Although

Fig. 22: Samuel Beckett and Thomas MacGreevy in London, c.1934. Courtesy Margaret Farrington and Robert Ryan

Beckett's interest in contemporary *avant garde* artists such as Avigdor Arikha, Alberto Giacometti, Henri Hayden, and of course Jack B. Yeats, was well known, it was only after the biographical research carried out by James Knowlson, making use of Beckett's letters to MacGreevy and his German trip diaries, that the full extent of his interest in and debt to classical painting was fully appreciated.[33]

Beckett's knowledge of and delight in the visual arts is an abiding presence in the correspondence. Beckett could assume that MacGreevy knew many of the paintings about which he was writing either in the original or in reproduction. At times his breathless narrative conveys the almost physical impact the art had on him, as in this passage about the Kaiser Friedrich Museum at Berlin:

> An exquisite Masaccio predella to the London Madonna, and a separate picture of a woman lying in receiving visitors. Wonderful Signorellis ... especially the big Pan as God of Nature and Master of Music, with a shepherd very like the El Greco son of Laocoon in London. The two del Sartos are the best I have seen, one a portrait of the del Fede. Practically a repetition of the Savoldo Magdalene in London, the same lovely pearl-yellow

cloak and hastening figure, only called here Venetian woman. Roomfuls of Botticellis and Bellinis, including a wonderful Pieta given to old Jacopo, very Paduan. A Butinone Pieta that bears out the little picture in London, Turas, Crivellis, Vivarinis, Ercole des Robertis, rather unassuming Mantegnas and a prodigious Carpaccio Entombment. The usual acres of Titain [Titian] at his best, if you like that kind of thing, I haven't been able to look at him for very long this trip ...[34]

The Second World War and its aftermath ruptured their friendship. MacGreevy helped to evacuate the paintings from the National Gallery in London to Wales during the Blitz. Afterwards, lecturing at the National Gallery in London ceased, and his income from reviewing art exhibitions was not enough to sustain him. In 1941 he returned to Dublin, where he quickly found work with the Capuchin Order writing for *The Father Mathew Record* and *The Capuchin Annual*, as well as reviewing art exhibitions for the *Irish Times*. Beckett, after watching his Jewish friends being rounded up on the streets by the Nazis and deported to concentration camps, joined the Resistance cell 'Gloria SMH', and worked translating and synthesising

intelligence reports for the British until the cell was infiltrated in August 1942. Beckett, and the woman with whom he was living, Suzanne Deschevaux-Dumesnil (who in 1961 became his wife), were lucky to escape (as many members of their cell were deported) eventually finding refuge in the small village of Roussillon in unoccupied France, where they waited out the end of the conflict.[35]

On his first trip to Dublin after the war, Beckett found MacGreevy to be part of a world he had forsaken, committed to an Ireland in which he wished to have no part. He could not but be pleased for MacGreevy, but he was also clearly saddened that the distance between them intellectually and emotionally was one which could not be bridged, or which he did not have the strength to bridge:

It gave me great pleasure to find you again after so long, not very changed, happier apparently and among your own people. Take care of yourself & let us keep in touch.

It was one of the few letters signed 'Yrs affectionately, Sam'.[36]

By the 1950s, belated financial and professional success came to both men. In 1950, at the age of fifty-seven, MacGreevy was appointed Director of the National Gallery of Ireland (fig. 23). The Gallery became his vocation and his passion, and he worked tirelessly to bring it into the twentieth century, planning the construction of what became known as the 1968 wing, instituting a regular lecture series (with one lecture a month in Irish), creating an in-house restoration department, and convincing the authorities to make the Directorship a full-time post.

Beckett finally achieved success as a writer. His letters, particularly from the 1960s, bemoan the time spent away from writing attending to translations, publishers, theatre directors and producers, and the seemingly never ending stream of visitors wishing to interview him. When in 1958 MacGreevy suffered his second heart attack, Beckett wrote:

I won't try and tell you what I feel, because you know, and between us the big words were never necessary. Doctors can deal with these things now and I know you'll be all right... I know how difficult it is to be careful, for

one who never spared himself ... You're a man much loved and much needed, don't forget that.[37]

In 1961 MacGreevy was successful in petitioning the Irish government to submit the work of Jack B. Yeats as the Irish contribution to the Thirty-First International Biennial Exhibition of Modern Art in Venice. MacGreevy was appointed Commissioner to the exhibition, and worked tirelessly, under severe financial and time constraints, and with his own health deteriorating, to oversee the show. In May 1962, Suzanne Beckett joined MacGreevy in Venice (fig. 24), although Beckett begged off, preferring to remain at his modest country retreat in Ussy: '[t]oo much in Paris at that time and in any case too frightened of the Press'.[38]

The following year, after continuing bad health, MacGreevy resigned from the Gallery. Feeling the breath of the grim reaper about him, MacGreevy began writing his memoirs, but the effort often exhausted him. Beckett, who had used a tape recorder as a prop in, rather than a compositional device for, *Krapp's Last Tape*, offered to send MacGreevy one on several occasions: 'I'd love to give you a tape-recorder if you think you could use it for composition - dictate into it and get someone to type it out for you. It might tire you less than pen and paper.'[39]

In March 1967 MacGreevy went into Portobello Nursing Home for a routine operation. He told his family of a premonition that he would never leave the room alive, as it was the same room in which Jack Yeats spent his last months. Several days after the operation, he suffered a heart attack and quietly passed away during the night. He was buried in Glasnevin cemetery. The wreath sent by Beckett lay beside the coffin, and on the wind was the whisper of many absent friends, both living and dead. Beckett, who could not attend the funeral, was distraught. For many weeks he thought of MacGreevy who, for forty years, had been an important part of his life. He retreated to Ussy, where he could be alone with his thoughts, feeling confused and in need of silence.[40]

When MacGreevy's will was read, it was discovered that, of all the correspondence in his collection – letters from T.S. Eliot and Jack B. Yeats, Wallace Stevens and James Joyce, W.B. Yeats and Marianne Moore – the one collection

specified in his will to be left to Trinity College, Dublin, was his letters from Samuel Beckett. The bequest came with the proviso that, if Beckett did not want them seen during his lifetime, they would remain inaccessible to scholars until after Beckett's death. The letters are a remarkable record, documenting Beckett's own journey told to someone with whom he was completely himself, no topic being too large or too small, no detail too personal to omit. His letters, from almost the first to the last, began 'My dear Tom', at a time when Beckett knew he had reached a level of intimacy with Joyce when the 'Mister' was dropped and he was simply referred to as Beckett.[41] He ended letters 'Love ever, Sam', or simply 'Love Sam' (after the war, the letters ended 'much love from us both').

MacGreevy knew when to challenge Beckett and when to give support. When Beckett's critical monograph on Proust was published in 1931, MacGreevy sent Beckett the encouragement he needed. Beckett replied to him:

'A thousand thanks for all you say about my Proust. … After reading your appreciation of that essay I know that it is worth more than I thought.'[42] The encouragement, however, worked both ways. When MacGreevy's monograph on T.S. Eliot was published in the same Dolphin series the previous month, Beckett wrote 'The Eliot left me with an impression of enviable looseness & ease … Altogether I envy you an essay that has so much unity of atmosphere & terrain & sincerity, and your long arms that fetched so much colour.'[43]

Beckett relished the subtlety and suppleness of MacGreevy's mind. He was Beckett's first mentor in art, and in life, and Beckett could be sure of the confidences MacGreevy would keep. Writing to MacGreevy was like writing to himself, only better, because MacGreevy wrote back.[44]

Fig. 23: Thomas MacGreevy outside the National Gallery of Ireland, 1950s. Courtesy Margaret Farrington and Robert Ryan

Fig. 24: Thomas MacGreevy and Suzanne Beckett in Venice for the 1962 Venice Biennale. Courtesy Margaret Farrington and Robert Ryan

1 Trinity College Dublin (TCD) Board Minutes Book, 19 March 1927, TCD MUN/V/5/23

2 TCD Board Minutes Book, 22 January 1927, TCD MUN/V/5/23

3 TCD Board Minutes Book., 1 October 1927, TCD MUN/V/5/23

4 James Knowlson, *Damned to Fame: The Life of Samuel Beckett* (Bloomsbury, London, 1996), p. 87

5 Knowlson 1996, p. 90

6 James Knowlson and Elizabeth Knowlson, *Beckett Remembering:Remembering Beckett. A Centenary Celebration* (Arcade Publishing, New York, 2006), p. 33

7 Knowlson 1996, p. 90

8 Georges Belmont, who studied with both Beckett and MacGreevy at the École, changed his name from Pelorson after the Second World War.

9 Interview with Georges Belmont by the author, Dublin 1991

10 Letter from Thomas MacGreevy to Jack B. Yeats, undated, with the first page missing: from contextual evidence, it is probably dated November 1930, National Gallery of Ireland, Yeats Archive.

11 Letter from Thomas MacGreevy to William Stewart, possibly 5 December 1928, private collection

12 Letter from Samuel Beckett to Thomas MacGreevy, 28 August 1934, TCD MS 10402

13 Letter from Thomas MacGreevy to Mr O'Connor, private collection

14 Susan Schreibman, 'Thomas MacGreevy, an Irishman; Richard Aldington, an Englishman' in A. Blayac and C Zilboorg (eds.) *Richard Aldington; Essays in Honour of the Centenary of his Birth* (Université Paul Valéry, Montpellier, 1994), p. 120

15 Richard Aldington, *Life for Life's Sake: a Book of Reminiscences* (The Viking Press, New York, 1941), pp. 353-54

16 Letter from Beckett to MacGreevy, undated (probably late September 1930), TCD MS 10402

17 Letter from Beckett to MacGreevy, 5 October 1930, TCD MS 10402

18 *ibid.*

19 See, for example, letter from Beckett to MacGreevy, 14 November 1930, TCD MS 10402

20 For more on the Yeats/MacGreevy relationship, see Susan Schreibman, 'Jack B. Yeats and Thomas Mac Greevy', *Irish Arts Review*, vol. 22, no. 1 (Spring 2005), pp. 96-99

21 Letter from Thomas MacGreevy to Jack B. Yeats, probably November 1930, National Gallery of Ireland, Yeats Archive

22 Letter from Thomas MacGreevy to Jack B. Yeats, 22 December 1930, National Gallery of Ireland, Yeats Archive

23 Letter from Samuel Beckett to Thomas MacGreevy, 3 February 1931, TCD MS 10402

24 Bruce Arnold, *Jack Yeats* (Yale University Press, New Haven and London, 1998), p. 264

25 Letter from Samuel Beckett to Thomas MacGreevy, 5 May 1935, TCD MS 10402

26 Letter from Samuel Beckett to Thomas MacGreevy, 29 January 1936, TCD MS 10402

27 Letter from Samuel Beckett to Thomas MacGreevy, 7 May 1936, TCD MS 10402

28 Letter from Samuel Beckett to Thomas MacGreevy, (Saturday 18) August 1932, TCD MS 10402

29 Thomas MacGreevy, unpublished memoir, private collection

30 Knowlson 1996, p. 146

31 Knowlson 1996, p. 160

32 Letter from Samuel Beckett to Thomas MacGreevy, 29 January [1935], TCD MS 10402

33 See particularly chapter two in James Knowlson, *Images of Beckett* (Cambridge University Press, Cambridge, 2003)

34 Letter from Samuel Beckett to Thomas MacGreevy, 18 January 1937, TCD MS 10402

35 For more information about Beckett's experiences during the Second World War, see Knowlson 1996.

36 Letter from Samuel Beckett to Thomas MacGreevy, 8 June [1945], TCD MS 10402

37 Letter from Samuel Beckett to Thomas MacGreevy, 29 March 1958, TCD MS 10402

38 Letter from Samuel Beckett to Thomas MacGreevy, 31 May 1962, TCD MS 10402

39 Letter from Samuel Beckett to Thomas MacGreevy, 17 May 1965, TCD MS 10402

40 Knowlson 1996, p. 549

41 Richard Ellmann, *James Joyce* (Oxford University Press, Oxford, 1982), p. 648

42 Letter from Samuel Beckett to Thomas MacGreevy, 11 March 1931, TCD MS 10402

43 Letter from Samuel Beckett to Thomas MacGreevy, 3 February 1931, TCD MS 10402

44 Unfortunately, none of MacGreevy's letters to Beckett have been preserved.

Beckett's Dublin

Nicholas Allen

Our sense of a cosmopolitan Dublin, sophisticated in its entertainments, complex in its make up, seems very recent. Thinking back to those long decades from independence to the Celtic Tiger revives troubles best forgotten, an Irish century marked by Civil War, violence in the North, emigration, neglect. From this perspective we can understand why Samuel Beckett, like James Joyce, left Dublin for Paris, his freedom found, we believe, in boulevards far from Foxrock, the suburb of his youth. To see this past as one of exile and disillusion is, I think, to miss part of the positive complication that local place, the known world, provided for Beckett in his early work. In what follows, I want to suggest points where Beckett, his writing, his milieu, coincide, and collide, with another Ireland, another Dublin, volatile and shifting, a Dublin where protest was entertainment, where writers, painters and musicians made their ties from disaffection. In this Dublin, Micheal MacLiammoir remembered, were 'saxophones … and skirts ever waxing', the whiskey fuelled talk of 'the merits of Joyce and Picasso'.[1] In this Dublin, cinemas showing the FA Cup final were attacked, and statues of past British Royals were destroyed (a fountain of Edward VII was blown up, while a statue of William III met its fate in College Green).[2] In this Dublin, the brothel quarter, known popularly as the Monto, was cleared out even as the public flocked to visiting cabaret in the Mansion House, large crowds drawn to the coded erotics of music and dance, the Athos Beauties singing 'Wonderful Girls' before Leon Lewisoff and Izna Rossell danced 'an exciting acrobatic waltz'.[3] Finally, devotees of the high life were treated to 'the re-running of the Irish Derby at the show after midnight. The artistes all donned imitations of the different owners' colours, with paper jockey caps, and raced around the floor'.[4]

This contested, vibrant, chaotic Dublin registers in Samuel Beckett's writing. It subsists in the racing cars, the affairs and the drunken conversations of Beckett's *More Pricks than Kicks*, first published in 1934 after a difficult composition. (Beckett told Thomas MacGreevy when he had written five parts: 'But I don't think I could possibly invite a publisher to wipe his arse with less than a dozen'[5]). The kinetic disruptions of the independent

city echo in the young Beckett's sense of continual upset, his neck infections, heavy drinking and bereavement in the loss of his father all speaking to a shifting Ireland in which everything is slightly out of place. A sense of unease extends to Beckett's stays elsewhere. In London, 'I really dread going back to Dublin and all that, but there is nothing else for it at this stage'.[6] In Dublin, Paris is 'about the last place in the world I want to go. Too many Frenchmen in the wrong streets'.[7] Beckett preferred cycle rides to the Enniskerry Arms for a drink with Con Leventhal to facing his contemporaries. With Liam O'Flaherty, Harry Kernoff and Austin Clarke crowding the haunts of the literati, 'Pubcrawling is impossible in this town now'.[8] 'I'll drink in Phibsborough or in my room'.[9]

Evident from Beckett's letters, and from his early prose works, *More Pricks than Kicks* and *Murphy*, first published in 1938, is his attempt to rethink the problem of place in this fractured world. His imagination ranged widely, books an occasional escape from his all too familiar funks. 'I have been reading wildly all over the place', he wrote to MacGreevy from his parental home, 'Goethe's Iphigenia & then Racine's to remove the taste, Chesterfield, Boccaccio, Fischart, Ariosto & Pope!'[10] His responses had a painter's palette, 'Pope says bright or white, Goethe golden and Hugo vermeil'.[11] The visual image became, in this early Beckett, a means by which to refigure established relations between seer and seen. Painting and sculpture allowed Beckett to think of silent meaning, to reflect on the transparent absurdity of our own projections onto the field of art. And the artists that Beckett responded to, say Paul Cézanne and Jack Yeats, are those who play with the problems of presence. The locations of such presence shift, from artist to critic, from person to person, the work of art a multiple co-ordinate in a fragmentary map. Beckett explored this displacement in a dense, difficult letter to Thomas MacGreevy in which he tried to express his own sense of disconnection from the landscape in which he found himself. There was no way for Beckett to represent true feeling.

I felt that discrepancy acutely this last time in Dublin, myself as exhausted of meaning by the mountains,

my madness at being chained to the car of my fidgets. And the impressionists darting about & whining that the scene wouldn't rest easy! How far Cézanne had moved from the snapshot puerilities of Manet & Cie when he could understand the dynamic intrusion to be himself & a landscape to be something by definition unapproachably alien.[12]

This perception of distance has led, I think, to the idea that Beckett was detached, specifically, from Dublin. A case might be argued otherwise that Beckett's alienation was informed by his Irish experience, the distance between idea and reality disturbingly, and monumentally, apparent in the construction of the post-independence state. This idea speaks to Beckett's obsession with the multiple spaces of political geography in his early work. Over and over, we are taken to places that, in their first perception, move us somewhere else immediately. St Stephen's Day 1932 found Beckett in Donabate, walking 'all about Portrane Lunatic Asylum in the rain'[13]. Talking to a passer-by, he asked 'about an old tower I saw in a field nearby. "That's where Dane Swift came to his motte" he said. "What motte?" I said. "Stella"'.[14] The event has echo in *More Pricks than Kicks*.

> Belacqua asked was the tower an old one, as though it required a Dr Petrie to see that it was not. The man said it had been built for relief in the year of the Famine, so he had heard, by a Mrs Somebody whose name he misremembered in honour of her husband.[15]

The associative transition from Beckett's walk to the tower to Jonathan Swift (now Dane, not Dean, the earlier invader inscribed in the later) to Dublinese to the antiquarian Dr Petrie to the Famine to memory makes a molecular thread of Ireland, its culture and history. That thread leads nowhere, and is too thin to hold the weight of meaning – how we put the parts together, and in what sequence, depends on infinite variables, our knowledge, our attention, our interest. Beckett's vision of Dublin, and its environs, is marked recurrently by such disruptive suggestion. Read, for example, a passage from *Murphy*,

where the character of Neary finds himself in unlikely trouble in the General Post Office.

> In Dublin a week later, that would be September 19th, Neary minus his whiskers was recognised by a former pupil called Wylie, in the General Post Office, contemplating from behind the statue of Cuchulain. Neary had bared his head, as though the holy ground meant something to him. Suddenly he flung aside his hat, sprang forward, seized the dying hero by the thighs and began to dash his head against his buttocks, such as they are. The Civic Guard on duty in the building, roused from a tender reverie by the sound of blows, took in the situation at his leisure, disentangled his baton and advanced with measured tread, thinking he had caught a vandal in the act. Happily Wylie, whose reactions as a street bookmaker's stand were as rapid as a zebra's, had already seized Neary round the waist, torn him back from the sacrifice and smuggled him half way to the exit.[16]

The General Post Office is site of the Easter Rising, the central location of revolutionary rhetoric from which Pearse launched his proclamation of an imaginary republic. That sacrificial history is embodied in Oliver Sheppard's statue of Cuchulain, which was unveiled there with military ceremony on 21 April 1935.[17] Beckett picks up on this Cuchulain's weakness, his buttocks 'such as they are'.[18] Playing on physical failure, Beckett hints at the famine that made for the necessity of Cuchulain as superhuman in the first place. The statue becomes symbol of a continuing death that rests uneasily in the information exchange of the independent capital, a tremor in every telegram.

A visual equivalent to Beckett's inquiry into the form of revolution, and its aftermath, can be found in one striking sketch by Jack Yeats, Beckett's friend and contemporary. The two met throughout the 1930s. Beckett was shyly enthusiastic about Yeats and was immediately taken with one 'small picture especially, Morning, almost a skyscape, wide street leading into Sligo looking west as usual, with boy on a horse, 30 pounds'.[19]

Fig. 25: Jack B. Yeats,
A Morning, 1935-36,
oil on board, 23 x 36cm,
National Gallery
of Ireland

In *A Morning* (fig. 25) Yeats' bright rider has his shadow on the ground behind him, a skeletal afterimage that shades against the painting's warming yellow. This eye for the haunted imprint reflects Beckett's own observations into the roots of Irish independence at the General Post Office, a place in Yeats' memory as he drew during the aftermath of the Civil War, perhaps because he only now began to process the event in context of a fragmented independence. One of Yeats' sketch books, now in the Yeats archive at the National Gallery of Ireland, pictures a journey to a city centre ravaged from the rebellion and its suppression. The broken thoroughfare outside the General Post Office is caught with dissolving detail in 'Dublin from O'Connell Bridge May 12 1916' (fig. 26),[20] the precise date and location significant of a practice that works between the experienced and the imagined, a practice that forces the events of the time between on the time represented. May 12 1916 is a continuing day, memory here is the medium between process and outcome, history and a present still not determined. In this Yeats reworks a public space, much as Beckett did with Cuchulain's statue.

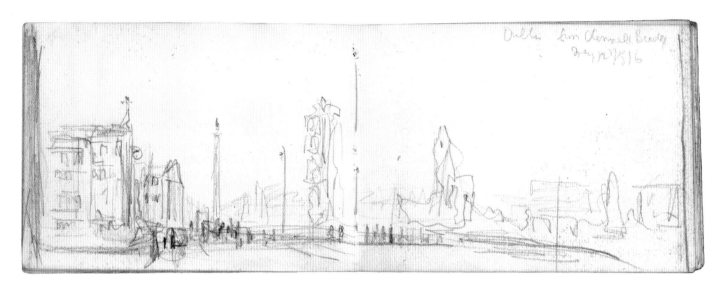

Fig. 26: Jack B. Yeats,
'Dublin from O'Connell
Bridge, May 12 1916',
*Dublin 1925 and
Some Greystones*,
Sketchbook 138, 1925,
pencil on paper,
8.7 x 25 cm, National
Gallery of Ireland

In a ghostly sketch that flits across two pages, looking from left to right, the mournful façade of the General Post Office is viewed from the perspective of Westmoreland Street, across what is now O'Connell Bridge to the north side beyond. The right side trails off in broken buildings, gesturing in this way to the open space of the north docks, where the Liffey melts into the sea, as it does in so many other of the sketches, and as it does in Joyce. People mill about as definite black vertical lines, and a sense of funeral attendance is reiterated by the black border that frames the left near side of perspective, a building site that looks like the edge of a mourning card. Overall, the drop from buildings that still stand to those destroyed suggests a movement that continues beyond the immediate, into an upset landscape whose contours Beckett recognised.

Recurrent throughout the sketchbooks of Yeats' works in progress, mostly in pencil, occasionally in colour, are those breaks in memory and understanding that signify the combination of politics and form in the landscapes of Yeats' viewing. These intrusions mark Yeats' traverse of a new geography post-independence, of a Dublin extended to its suburbs, much as the Liffey splits and fragments from *Ulysses* to *Finnegans Wake*. This dissipation, set at the limits of the new capital, finds its voice in Beckett's early works. *More Pricks than Kicks* is first set in Portrane and Fingal, while 'Serena III', from *Echo's Bones*, a signed copy of which Beckett sent to Yeats, inhabits a similar, motive geography.

whereas dart away through the cavorting scapes
bucket o'er Victoria Bridge that's the idea
slow down slink down the Ringsend Road
Irishtown Sandymount puzlle find the Hell Fire
the Merrion Flats scored with a thrillion sigmas
Jesus Christ the Son of God saviour His Finger
girls taken strippin that's the idea on the Bootersgrad
breakwind and water the tide making the dun gulls
in a panic the sands quicken in your hot heart
hide yourself not in the Rock keep on the move
keep on the move.[21]

Yeats sketchily negotiated this peripheral city in the quick sweeps of his pencil, with keys to colour indicated by the writing of grey, blue and black on the page. Sometimes the images stretch horizontally across two pages, each three and a half by five inches in scale. These miniatures of a new landscape mirror, in their way, the fragilities of a Giacometti, that delicate balance between absence and presence with which Yeats' sketches play. All are of the moment, a *flânerie* of impressions that register Ireland's changing state. The overall sense of crossing the island, from the eastern city to the western seaboard, enacts a general tendency in Irish culture post-independence to map the contours of the new state.

Striking in any review of Irish books in the period, say the *Dublin Magazine* or *Irish Book Lover*, is the amount of publications dedicated to the representation of local place. The memoirs of revolutionary activity that began to sell after the Civil War, Frank Gallagher's *Days of Fear*, Dan Breen's *My Fight for Irish Freedom* and, best of all, Ernie O'Malley's *On Another Man's Wound*, operate from a knowledge of geography transformed from the idyllic western visions of a Paul Henry to the pulsating landscapes of Jack Yeats, the flying columns disappearing into mountain ranges whose foggy deeps hide more than a Celtic otherness.

On Another Man's Wound contains sketches of landscape that combine the perspectives of artist and revolutionary. Guiding you through the Irish countryside from month to month, from the hardships of winter to the slow promise of spring, O'Malley draws a place coherent

with Jack Yeats' western landscapes.[22]

Wet days when soft, gentle rain fell unnoticed until one realised that clothes had become sodden; stinging rain that whipped the face and stung, teeming on the land, but with a taut challenge that one accepted. Hands became blue on the handlebars and, it was hard to draw a gun quickly, gloves were in the way of a grip. November brought more stillness and the delicate softness of late autumn sky, with its nonchalant disturbance by wind. The bare strength of the country showed lean and hardy, form was more emphasised with the dropping of the more eye-filling beauty of colour and covering.[23]

Irish culture of the 1920s and 30s was formed on images of resistance and remembrance such as O'Malley imagines. This begins to explain the attraction Yeats' work had for many of those whose sympathies were not with the new state in Ireland, for whatever reason. And this determination not to dictate by meaning is what informs Beckett's own, later, observation.

It is difficult to formulate what it is one likes in Mr Yeats's painting, or indeed what it is one likes in anything, but it is a labour, not easily lost, and relationship once started not likely to fail, between such a knower and such an unknown. There is at least this to be said for mind, that it can dispel mind. And at least this for art-criticism, that it can lift from the eyes, before *rigor vitae* sets in, some of the weight of congenital prejudice.[24]

Alive because incipient, the sketchbooks suggest a continuing quarrel with the world as it presents itself, drawing a delicate re-ordering of the way things are. This continued resistance spoke to a constituency, including Beckett and Joyce, uneasy with what they perceived to be the limited forms and apparent brutality of a dubious freedom. A growing relationship between Beckett and Yeats suggests a further, elusive correlation between their practice and place. Yeats' own copy of

Murphy has, attached to its first page, a newspaper cutting of Samuel Beckett's poem *Saint-Lô 1945*.

> Vire will wind in other shadows
> unborn through the bright ways tremble
> and the old mind
> ghost-abandoned
> sink into its havoc
> no other mark[25]

Beckett's poem generates suggestions in a way similar to Yeats' paintings; without the key of a title there would be little evidence from which to proceed. Knowing that Beckett is writing from his own experience in the hospitals of Saint-Lô in the last days of the Second World War, it is possible to imagine a sense of the new mentality needed to process a world in recovery. This does not explain Beckett's poem. 'Vire' is too obscure a sign, throwing the definite direction of 'will' off track. The failure of memory, 'ghost-abandoned', suggests a definite break between past and present, but with a future so unsure the poem remains, as it intends, an anxious signal that 'means' only in that immediate, lost, moment of time and place, Saint-Lô, 1945. This provisional aesthetic disallows definite identifications. What can be connected to the Dublin, and the Ireland, of Beckett's writings on art and literature is the surprising sense of anticipation allowed for in painting's and writing's refusal to determine meaning, to close off options. Presence is established, yes. Boundaries are not. Dublin's General Post Office, in Beckett, as in Jack Yeats, is one site of a revolution yet to happen, a possible place for an Ireland still to be imagined, a liberty extended, even yet, to us all.

1 Micheal Mac Liammoir, 'The Hectic Twenties', *Motley*, 1 (7 December 1932), p. 11
2 Fearghal McGarry, 'Too Damned Tolerant': Republicans and Imperialism in the Irish Free State', *Republicanism in Modern Ireland* (ed. Fearghal McGarry) (UCD Press, Dublin, 2003), p. 66
3 *Irish Independent*, 26 June 1925, p. 10
4 *ibid*.
5 Letter from Samuel Beckett to Thomas MacGreevy, 13 May 1933, TCD MS 10402
6 Letter from Samuel Beckett to Thomas MacGreevy, 18 August 1932, TCD MS 10402
7 *ibid*.
8 Letter from Samuel Beckett to Thomas MacGreevy, 1 January 1932, TCD MS 10402
9 Letter from Samuel Beckett to Thomas MacGreevy, 9 October 1931, TCD MS 10402
10 Letter from Samuel Beckett to Thomas MacGreevy, 25 March 1936, TCD MS 10402
11 *ibid*.
12 Letter from Samuel Beckett to Thomas MacGreevy, 8 September 1934, TCD MS 10402
13 Letter from Samuel Beckett to Thomas MacGreevy, 5 January 1933, TCD MS 10402
14 *ibid*.
15 Samuel Beckett, *More Pricks than Kicks* (Picador, London, 1983), p. 26
16 Samuel Beckett, *Murphy* (John Calder, London, 1977), p. 28
17 John Turpin, *Oliver Sheppard 1865-1941: Symbolist Sculptor of the Irish Cultural Revival* (Four Courts Press, Dublin, 2000), p. 139
18 Beckett, *Murphy*, 1977, p. 28
19 Letter from Samuel Beckett to Thomas MacGreevy, 29 January 1936, TCD MS 10402
20 'Dublin 1925 and Some Greystones', Sketch Book 138, National Gallery of Ireland, Yeats Archive
21 Samuel Beckett, 'Serena III', *Collected Poems in English and French* (John Calder, London, 1977), p. 35
22 Richard English writes that Yeats imagined 'in vividly evocative, sensitive ways the distinctively local Ireland which the Republicans helped to create'. *Ernie O'Malley. IRA Intellectual* (Clarendon Press, Oxford, 1998), p. 164
23 Ernie O'Malley, *On Another Man's Wound* (Anvil Press, Dublin, 1979), p. 140
24 Samuel Beckett, 'MacGreevy on Yeats', *Jack B. Yeats: A Centenary Gathering* (ed. Roger McHugh) (Dolmen Press, Dublin, 1971), p. 78
25 Samuel Beckett, 'Saint-Lô 1945', *Irish Times*, 25 January 1946. Clipping inside Yeats' personal copy of Samuel Beckett, *Murphy* (Routledge, London, 1938), National Gallery of Ireland, Yeats Archive

Republics of Difference: Yeats, MacGreevy, Beckett

David Lloyd

This essay is an attempt to understand Samuel Beckett's peculiar and surprising homage to Jack B. Yeats through an approach to what he may have seen in the paintings as formally significant work. Beckett's remarks in his two published notices are not only too brief but also too characteristically enigmatic and reserved for us to do more than speculate on the grounds for Yeats' apparently powerful impact on him. But the writer's capacity for *attention* to visual work is notorious, and it is clear that his regard for the paintings that he valued was based on the significance of their forms rather than on any symbolic or allegorical meaning they might hold.

The dominant view of Yeats as a symbolic or representative painter, which gave occasion for Beckett's first extended remarks on the painting, is that of their mutual friend Thomas MacGreevy. What Beckett in his 1945 review of MacGreevy's book on Yeats cites as its principal argument is the conviction that Jack B. Yeats is, in every sense, *the* representative painter of the Irish nation 'the painter who in his work was the consummate expression of the spirit of his own nation at one of the supreme points in its evolution'.[1] For MacGreevy, Yeats is the first and quintessential national painter; for Beckett, Yeats explores rather what he had described in a 1934 review, 'Recent Irish Poetry', as 'the new thing that has happened, or the old thing that has happened again, namely the breakdown of the object' or 'the breakdown of the subject' – in either case, the rupture of communication.[2] And, already in 1934, it is 'a picture by Mr. Jack Yeats' that he invokes, alongside T.S. Eliot's *The Wasteland*, as exemplary of this awareness. Yeats' paintings become the contested zone of two radically opposed conjunctures of aesthetic and political principles.

But doubtless, in following the terms that Beckett establishes in his review of MacGreevy on Yeats, one is drawn to exaggerate the differences. While Beckett's contempt for the Saorstat (the post-treaty Irish Free State) has often been foregrounded, less has been made of the longstanding republicanism that MacGreevy and Yeats shared and which forms a barely occluded subtext of the essay. In the wake of the Civil War, which pitted republican radicals against the forces of the new Free State – to which MacGreevy refers disparagingly as 'the little almost republic of Ireland' – the identification of nationalism and republicanism is no simple matter.

Indeed, MacGreevy's essay on Yeats not only makes no secret of his political affiliations, but insists on articulating both a republican interpretation of recent Irish history and his sense of the relation of Yeats' work to republicanism. Both stylistically and politically, MacGreevy suggests, Yeats' work is a refusal of the status quo, of the state that is in being. He is committed, rather, to the Ireland of the dispossessed, of the landless labourers and the workers, of the marginal people, the 'tinkers' and tramps, the rogues and derelicts, the ballad singers and roving musicians that populate Yeats' pre-war images of Ireland and who, in actual practice, so often proved recalcitrant to assimilation into the official nationalist movement with its need to refine and purify the spirit of the nation. The pointers throughout MacGreevy's essay ask us to re-examine the pre-1922 body of Yeats' work in Ireland, on which, rather than on the later and most formally innovative paintings, his reputation as Ireland's foremost *national* painter remains based. The most cursory survey of Yeats' earlier drawings, paintings and illustrations of Irish material indicates the function of containment that operates in the selection and dissemination of his work. A full sense of his engagement with a certain demotic, or even daemonic, energy in the margins of Irish life seems to slip away through the refining filters of selection that singularly reduce the prominence in his work of the marginal, unruly figures he so often chooses to portray.

If these works are, as they are, representations of those who 'cannot represent themselves' and therefore 'must be represented', they are no less representations of that which eludes representation, which disappears from representation even in the glare of what it renders visible. It is no paradox, then, that, as MacGreevy seems to suggest, the condition under which Jack Yeats becomes the representative national painter is precisely that of a failure of representation, one in which the *'petit peuple'* is set over against 'an unrepresentative possessing class' and in which 'Those who acted for the nation officially were outside the nation'.[3] The counter-revolutionary Free State does not, from a republican perspective, overcome that rift

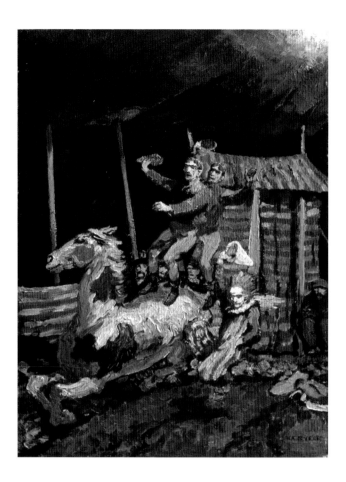

Fig. 27: Jack B. Yeats,
Double Jockey Act, 1916,
oil on canvas, 61 x 46 cm,
National Gallery of
Ireland

in representation, but in a sense exacerbates it, dividing the people from itself rather than unifying it, as a decolonising nationalism seemed to, against the imperial power.

Indeed, it is precisely here that Beckett and MacGreevy converge, in their recognition of Yeats' recalcitrance to any mode of premature reconciliation, as symbolised by the relation of figure to landscape in his work. Where Beckett apprehends this in terms of the 'petrification' of figure and landscape, MacGreevy approaches it through what he understands as Yeats' singular innovation in the history of painting, the striking of 'a new balance between the landscape and the figure':

> With Jack Yeats, the landscape is as real as the figures. It has its own character as they have theirs. It is impersonal. They are the reverse. But the sense of the impersonal is an enrichment of the humanity of the figures. And conversely, the opposition heightens the sense of the impersonal character of the landscape. … I do not think I am claiming too much for Jack Yeats when I say that nobody before him had juxtaposed landscape and figure without subduing the character of either to that of the other. … Association and apartness at one and the same time have never been more clearly stated in terms of art.[4]

MacGreevy's is an extraordinary insight into a quality of Yeats' painting that underlies the dynamic of so many of his later paintings. What MacGreevy variously comprehends as balance, or as 'association and apartness', seems to me to lie at the heart of the dynamic tensions that trouble the viewer's gaze before the most achieved of these canvases.

It is well known that the most immediately striking aspect of the transformation of Yeats' style across the 1920s is his gradual abandonment of line. The early oils are marked by the predominance of sharp outlines bounding the figures and the visual foci of the image, what Bruce Arnold aptly refers to as '*drawing* in oil paint'.[5] This is true not only for the illustrations to *Irishmen All*, whose technical qualities Arnold nicely analyses, associating them with the line drawing of *A Broadside* or with Yeats' experience of poster-work. It is no less true of free-standing

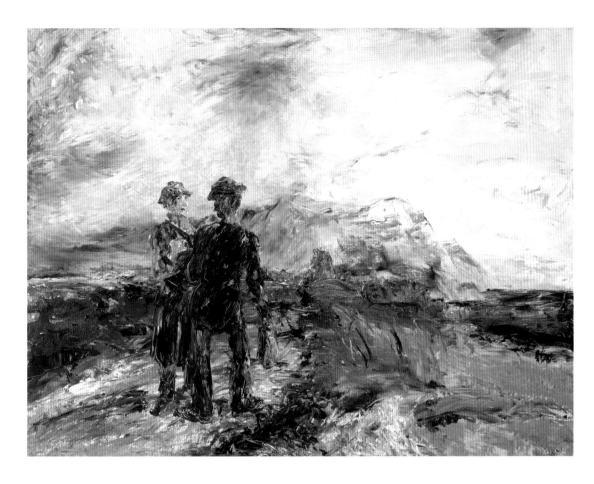

Fig. 28: Jack B. Yeats,
Two Travellers, 1942,
oil on canvas,
92.1 x 122.6 cm,
Tate, London

oil paintings like *Bachelor's Walk*[6] or *The Double Jockey Act*,
1916 (fig. 27). In the former, the figures of the flower girl
and the boy at her side stand out starkly from the street,
the pavement and the walls behind them, as if backlit,
or even as if collaged onto the already painted scene.
Here the figure stands out from its ground emphatically:
the clear outlines and the relief into which they throw the
figures against the background predisposes a painting like
Bachelor's Walk to being 'used as a nationalist ikon, and a
symbol'.[7] For the very 'standing forth' of the human figures
projects them into a representational status that is both
their 'standing for' the nation as its types and a mode of
pictorial clarity or accessibility.

This is not intended as a reductive characterisation,
but to mark the technical and formal transfiguration of
Yeats' work in both its radical nature and its political
significance. We are obliged to turn to the significance
of the actual mode of representation rather than to
the objects represented to grasp the import of the later

paintings, the way in which they seize and work on the
viewer's gaze.

Any number of Yeats' later paintings would serve to
exemplify the activity of the gaze that his canvases demand
and provoke, but one may serve as a telling instance.
Two Travellers, 1942 (fig. 28) is one of Yeats' better-known
paintings, partly because the Tate Gallery purchased
it, partly because it has been associated with the set of
Beckett's *Waiting for Godot*.[8] Thematically, the painting
resumes many of Yeats' visual preoccupations. Two men,
in well-worn clothing, encounter one another on a rough
track in a coastal landscape. Heavy clouds suggest an
imminent rainstorm, though the skyscape is lighter over a
choppy sea in what is presumably the West, where a faint
rose light illuminates the clouds and falls on one traveller's
face. The encounter remains an enigma: are they strangers
or acquaintances? Of what do they speak? How far are
they travelling? What brings them to this otherwise
desolate and apparently uninhabited terrain? Where

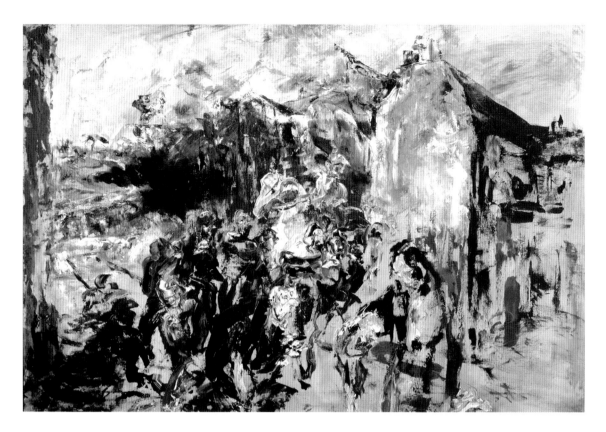

Fig. 29:
Jack B. Yeats,
Grief, 1951,
oil on canvas,
102 x 153 cm,
National Gallery
of Ireland

is each headed? And yet to turn from the thematic paraphrase of the painting (the aspect of the painting that reproduction tends to foreground by flattening out the texture of the medium) to its formal and technical qualities is to engage with a much less stable phenomenon that obliges what Beckett calls the 'labour' that is engaged 'between such a knower and such an unknown'.[9]

Confronting *Two Travellers*, one is almost certainly struck at once by the paint surface itself and by the difficulty of resolving the image out of the paintwork. The same effect can be observed in many of Yeats' late paintings, notably, for example, *Grief*, 1951 (fig. 29) or *Above the Fair*, 1946: it is often extremely difficult to achieve a total image of the painting no matter where one stands before the canvas. Wherever one stands, one has the impression of seeing the work at a different depth of focus, so to speak. It is as if the represented of the painting continually dissolves back into the medium of the representation, resisting totalisation and renewing the work of the gaze at every turn. In *Two Travellers*, not atypically, the layering of the oils is at very different thicknesses, ranging from the thinnest of layers

to a dense impasto. The grey cloudscape that stretches from the expanse of sky in the upper left corner across the line of the hill or mountain that becomes an abrupt cliff to the right is a thin film through which the bare canvas can at points be glimpsed. To the far mid-right, the dark blue of the sea is thickly layered, but scored at points by brush handle or palette knife to reveal bare canvas, producing the effect of lines of surf foam at the cliff's base. Just right of centre, along the side of the road or path that bisects the painting, an extraordinary stretch of primary colours – predominantly yellow, red and green – is dashed unmixed and thickly to the canvas and apparently, from the lack of brush-marks, applied directly from the tube or perhaps the finger to the canvas. Similar patches of bright primary colour appear to the left of the two figures, but in neither case do these vivid and heady patches of colour resolve into the conventional outlines of the vegetation they must be taken to represent. The thickest impasto composes the two figures. In evident contrast to the earlier oils, however, no firm bounding lines enclose them. On the contrary, they are composed largely out of the same oil tones as

the landscape immediately surrounding them; at points, such as the right leg of the left hand traveller, they are literally carved out of the depth of the paint by, presumably, the tip of the brush handle. The figures seem at one moment to be sculpted almost three-dimensionally out of the surface of the oil paint, at another to merge back into it, the figure becoming consubstantial with the medium. In such a technique, 'drawing in oils' takes on an entirely new meaning.

The mobility of the gaze that is obliged by this highly plastic application of the oils is reinforced by the overall composition of the painting. With an effect that is again largely lost in the flattening of reproduction, the canvas appears to be constructed of overlapping and competing zones of focus. While at one moment the two figures in the foreground appear to dominate, the eye is almost immediately led either to the upper left quadrant of the lowering sky by the figure's vertical posture, or by the intense primary colours to the roadway and then, by a sharp rightward turn of the line described by those pigments at the base of the cliff and its continuation in a fine line of red, to the sea- and skyscape of the upper right quadrant. These various zones of focus are not discrete, however, but overlap and penetrate each other while being linked by the roadway whose line of sight projects diagonally from the lower left through the standing figures towards the upper right. The effect of these distinct but overlapping compositional zones is to prevent the eye from coming to repose. In this sense, the painting forcefully confirms MacGreevy's insight, based on earlier work of Yeats', as to the 'balance' between figure and landscape, but does so in a way remarkably more dynamic in every respect. It is not only that within the representation the eye moves without dominative hierarchy between what would otherwise be ' figure' and 'ground', but that the gaze moves, is obliged to move, simultaneously between the representation, the image in the painting, and the medium of the representation, the material of the painting. The dimension of artifice, the material that composes the image, is not subordinated to the image: rather, its surfaces, depths and plastic textures are foregrounded in a way that dissolves the figure even as they supply the

medium through which it emerges. The oscillation of the eye between material and representation produces the paradoxical effect of suspension to which Beckett refers, like a sustained tremolo in musical composition.

This rigorous emphasis on the technical problems of representation constitutes the enduring difficulty of viewing Yeats' paintings as visual totalities: standing before his canvases, one is constantly forced to move back and forth between technique and image, figure and medium, undecided as to which dominates. Yeats' painting foregrounds its material conditions of representation with an effect that is the antithesis of mimetic reflection of the world. It is to this formal recalcitrance of Yeats' painting, rather than simply to any contingent affinity with his representations of tramps, clowns or derelicts, that we can most fruitfully trace Beckett's high estimation of the painter.

Through the 1930s and 1940s Beckett articulates the problem of the writer through what may have been for him at first a necessary distinction between language and its objects. As he writes in 1937 to his German friend Axel Kaun:

> And more and more my own language appears to me like a veil that must be torn apart to get at the things (or the Nothingness) behind it. … As we cannot eliminate language all at once, we should at least leave nothing undone that might contribute to its falling in disrepute. To bore one hole after another in it, until what lurks behind it – be it something or nothing – begins to seep through; I cannot imagine a higher goal for a writer today. Or is literature alone to remain behind in the old lazy ways that have been so long ago abandoned by music and painting?[10]

Language for Beckett at this point remains conceived of metaphorically as a *veil* between the object external to it and the representation that it constitutes, although the counter-analogy with music and painting suggests that he may already be grasping for a notion of an art in which there is no distinction between form and matter.

What is striking, however, is that despite the antagonism

to representation and to expression that informs his criticism of MacGreevy and his art criticism in general, Beckett does not turn for a solution where one might expect, to pure abstraction, but rather to artists who seem to be linked only in their exploration of the very limits of figuration: Yeats, Bram van Velde, and, later in his life, Avigdor Arikha. This is for Beckett the crux of the gaze that painting obliges in its staging of the undecidable relation between figure and medium: 'Whence comes this impression of a thing in the void? Of artifice [*de la facon*]? It's as if one were to say that the impression of blue comes from the sky'.[11] This perplexity as to the object of representation, in representation, and to its referents is bound up with the act of looking itself in which the viewer's disequilibrium becomes a kind of self-referential slapstick. Beckett's 'amateurs' in the museum or gallery 'look first from far away, then close up, and … in particularly thorny cases, assess with their thumbs the depth of the impasto'.[12] Though this passage concerns painting in general and the van Velde brothers in particular, perhaps no better or more succinct account of the process and difficulty of looking at a Yeats painting could be achieved.

But none of this resolves the question of the relation of the medium to the represented. Which is it that is recalcitrant, the figure that insists on its emergence or the medium into which again it dissolves before the oscillating gaze? For Beckett, this 'issueless predicament', the aporia into which so reflexive an artwork throws the viewer, is thoroughly melancholic. It is a condition that leads him to speak, writing still of the van Veldes, Geer and Bram, of '*le deuil de l'objet*', mourning for the object (or the mourning *of* the object – the ambiguity of the French genitive is carefully poised). This mourning is not one that can be alleviated, least of all by abandoning the attempt to represent:

> It seems absurd to speak, as Kandinsky did, of a painting liberated from the object. That from which painting is liberated is the illusion that there exists more than one object of representation, perhaps even of the illusion that this unique object would let itself be represented. …

For what remains of representation if the essence of the object is to abscond from representation?[13]

The persistence of an obligation to represent, because painting cannot be freed from the very object that eludes it, leads to a painting whose condition is a ceaseless unveiling that reveals only further veils, as if the medium cannot dispense with the medium that hinders its ends: 'An endless unveiling, veil behind veil, plane on plane of imperfect transparencies, an unveiling towards the ununveilable, the nothing, the thing yet again'.[14] This thing that insists and is at once no-thing, this thing that eludes representation, remains the melancholic 'core of the eddy',[15] encrypted beyond the reach of a subject that nonetheless cannot abandon the urge to capture it. Though it may seem absurd to align Jack B. Yeats with the van Veldes, whose work in quite different ways pushes the boundaries between figuration and abstraction to the very limit, yet it is the association that Beckett makes from the outset. All are painters whose work, like 'the best of modern painting', is a critique, a refusal 'of the old subject-object relation'. In each case, and not least in Yeats, it is the dynamic oscillation between material and image that sets that critique in play.

The dynamic of Yeats' paintings, then, is the enactment of a failure of representation, a failure either to retrieve or to abandon the object. The formal means employed in this virtually obsessive work of representation are at once the analogue and the performance of that predicament. We face, then, an oeuvre that answers in advance to Beckett's desire for an art that abandons the 'possessional' drive that has continually renewed western representational art.[16] The internal dynamics by which figure and ground, material and image, technique and content are suspended in an oscillating equilibrium correlates to a refusal of domination that is the aesthetic counterpart of a radical republicanism, a republicanism, that is, that remains profoundly at odds with the representational structures that undergird the cultural projects of nationalism and the modern state. I do not, evidently, mean to suggest that either Yeats or, least of all, Beckett, programmatically set out to subserve the political projects of Irish

republicanism, though Yeats' commitment to depicting the marginal sectors of Irish social life, urban and rural, has often enough been understood in those terms. It is, rather, that the post-colonial disaffection of both artists from the nation state that emerged stands not only as an acknowledgement of the failure of a certain political promise, but spells equally the disintegration of a related aesthetic project of representation.

The critical aesthetic impulse that draws together the painter Yeats and the writer Beckett dwells, with a certain compulsion born of necessity, on the ruins of representation that follow in the wake of the national project. It is not that either artist promotes an immediately cognisable political aesthetic. On the contrary, it is rather the inevitable imbrication of the political with the aesthetic within nationalism that makes of their intense preoccupation with the conditions of representation a deeply implicit political affair. Where an aesthetic of representation that had become tied to nationalist political thinking becomes, along with the political state, a means to domination, only in the ruins of that aesthetic can an alternative be excavated. The excavation that follows is at once positive and negative: positive in its making space once more for the recalcitrant, for figures of those that had been denied representation, the tramps, rogues and derelicts that populate both artists' works; negative, in the relentless interrogation of the *means* of representation that both engage formally and technically. Precisely the tension between the act of figuration and its formal questioning, however, prevents the dimension of the political in either artist's work from ever congealing into a concrete utopian project. The space of their work is, rather, the place made over and again for the unfit in representation, for those that dwell only among the ruins. In the ruins of representation alone, where the nation meets its end, the anticipatory trace of a republic emerges as that thing that yet eludes representation.

1 Samuel Beckett, 'MacGreevy on Yeats', *Disjecta: Miscellaneous Writings and a Dramatic Fragment* (ed. Ruby Cohn) (Grove Press, New York, 1984), p. 96; cited from Thomas MacGreevy, *Jack B. Yeats* (Victor Waddington Publications, Dublin, 1945), p. 10

2 Samuel Beckett, 'Recent Irish Poetry', *Disjecta*, p. 70

3 MacGreevy 1945, pp. 17, 9

4 *ibid*. pp. 13-14

5 Bruce Arnold, *Jack Yeats* (Yale University Press, New Haven and London, 1998), p. 180

6 Illustrated in Hilary Pyle, *Jack B. Yeats. A Catalogue Raisonné of the Oil Paintings* (Andre Deutsch, London, 1992), vol. 3, p. 41, no. 97

7 *ibid*. p. 191

8 See, for example, James Knowlson, *Damned to Fame* (Bloomsbury, London, 1996), pp. 378-79

9 Beckett, 'McGreevy on Yeats', *Disjecta*, p. 95

10 Samuel Beckett, Letter to Axel Kaun, 9 July 1937, *Disjecta*, pp. 171-72

11 Samuel Beckett, 'La peinture des van Velde ou le Monde et le Pantalon', *Disjecta*, p. 125 (my translation)

12 *ibid*. p. 120 (my translation)

13 Samuel Beckett, 'Peintres de l'Empêchement', *Disjecta*, p. 136 (my translation)

14 *ibid*. p. 137

15 The phrase comes from Beckett's essay, 'Proust', in *Proust and Three Dialogues with Georges Duthuit* (John Calder, London, 1976), pp. 65-66

16 Beckett, 'Peintres de l'Empêchement', *Disjecta*, p. 135 (my translation)

Beckett's first encounters with modern German (and Irish) art

James Knowlson

Beckett and William Sinclair's modern art collection

Samuel Beckett first came into contact with modern German art between 1928 and 1932 when he visited the town of Kassel to stay with his aunt and uncle, Cissie and William Sinclair. He went to Germany primarily to see his younger cousin, Peggy Sinclair, with whom he was having an intense, if turbulent, love affair.[1]

Peggy's father, known as 'Boss' Sinclair, was well known in Dublin as an antiques and art dealer. In Ireland, he was in touch with many contemporary artists, contributed art criticism to *The Irish Review* and wrote a little book entitled *Painting* (1918). In the early 1920s, he moved to Kassel, where he hoped to develop a career as an art dealer, specialising in modern German painting and sculpture. Sinclair himself owned quite a number of modern paintings, a few of which hung on the walls of their apartment or were stored, with the support of a friendly co-director of the art gallery, in Kassel's Städtische Galerie[2]: 'I have a large collection of mad pictures', he wrote dryly to the Irish painter, Estella Solomons, in April 1925, 'and it is always possible some loose lunatic will love one of them and give me money for it'.[3]

Few private individuals were purchasing modern art, however, at that time in the high inflation economy of post First World War Germany and, eventually, some of the paintings which belonged to Sinclair had to be sold at auction, before he fled the country with his family (largely because of debts, but also because, as a Jew, 'Boss' Sinclair feared the consequences of the Nazis' rise to power), returning to Ireland in 1933. In a letter to his close friend, Tom MacGreevy, written in December 1932, Beckett wrote: 'Cissie exhorts me to go to Kassel for Xmas, though they have scarcely a loaf between them and all the grand pictures have to go … '[4] Less than a month later, he commented sadly: 'Cissie writes; they are quite down now, piano, pictures and everything gone'.[5]

For most of their ten-year stay in Germany, indeed, the Sinclairs lived in a state of virtual penury. 'Boss' Sinclair was obliged to give private English lessons and work on the occasional translation in a vain attempt to pay the mounting bills.[6] Nonetheless, as Cissie's invitation to Beckett showed, they were still prepared to welcome him with open arms and 'Boss' Sinclair was just as generous with his time and his enthusiasms, sharing his passionate love for modern German art with his young nephew.

Sinclair was friendly in Kassel with a number of local German painters. Karl Leyhausen (1899-1931), who committed suicide in Paris at the age of 32, was one such caller at the Landgrafenstrasse apartment.[7] He was the artist friend who painted Peggy Sinclair in 1927 (fig. 30), wearing the green beret which was immortalised by Beckett as a semaphored adieu in *Dream of Fair to Middling Women*, the Smeraldina-Rima waving it frantically at Belacqua from the departing boat. ('The sun had bleached it from green to a very poignant reseda and it had always from the very first moment he clapped eyes on it, affected him as being a most shabby, hopeless and moving article.')[8] Another, now little known, artist friend was Ewald Dülberg (1888-1933), whose contemporary celebrity has been underestimated.

Yet another frequent visitor to the Sinclairs' apartment was the young Irish painter, Cecil Salkeld (1904-69), who, inspired by Otto Dix and by the Neue Sachlichkeit movement but especially by his teacher at Kassel's Kunstakademie, Ewald Dülberg, emerged as one of the most innovative of the few practising Irish Modernists, his paintings also revealing the likely influence of Italian *Pittura Metafisica* painters such as Giorgio di Chirico. Salkeld, was in, S. B. Kennedy's words, 'virtually the only Irish painter of his generation to look beyond France' – to Germany and Italy in fact – for inspiration.[9]

With the exception of two other highly talented Irish artists of the inter-war years, Evie Hone (1894-1955) and Mainie Jellett (1897-1944), who embraced the practices (and, in Jellett's case, the principles too) of French Cubism, the Dublin art scene in the 1920s while Beckett was studying French and Italian at Trinity College was largely representational, often fiercely nationalistic and resolutely anti-Modernist. One of the best known of the new Irish realists was Seán Keating, for whose painting Beckett expressed disdain, writing in a letter to Tom MacGreevy in 1931: 'I thought Orpen's Ptarmigan & Wash House [two paintings newly acquired by the National Gallery of Ireland] nearly as bad as Keating,'[10] Jack B. Yeats, on the

Fig. 30: Karl Leyhausen, *Peggy Sinclair*, 1927, oil on canvas. Courtesy, Marie-Renate Büttner

Fig. 31: List of Works Loaned by William Sinclair to the Städtische Galerie, Kassel, 28 July, 1930. Courtesy Städtische Galerie, Kassel

28. Juli 1930.

V e r z e i c h n i s

der aus dem Besitz von William A. Sinclair, Kassel Landgrafen-
strasse 5 als Leihgabe an die Städtische Galerie Kassel abzu-
gebenden modernen Kunstwerke.

			Versicherungs-wert:
1.)	Antes, Adam Darmstadt :	Frauentorso, rote Terrakotta	600.-- Mk.
2.)	Boccioni:	"Das Lachen" 1907, das erste futuristische Gemälde	5.000.-- "
3.)	Burchartz, Essen:	Damenbildnis vor blauem Hinter-grund	600.-- "
4.)	derselbe :	Mädchen in grünem Kleid beim Haarkämmen	600.-- "
5.)	Campendonk, Essen :	Waldvision	600.-- "
6.)	Dülberg, Ewald Berlin:	Das Abendmahl	2.000.-- "
7.)	Eberz, Josef, München :	Ruhende Tänzerin vor dumpfer Landschaft	600.-- "
8.)	Ewald, Reinhold Hanau:	Zwei Männer	600.-- "
9.)	Feininger, Lyonel Dessau:	Badende an der See	3.500.-- "
10.)	Kölschbach, Josef Köln:	Konversation	600.-- "
11.)	derselbe :	Weiter Innenraum	300.-- "
			15.000.-- Mk.

Der Direktor der Staatlichen Kunstsammlungen :

other hand, whose friend Beckett was later to become and for whose painting, *A Morning* (fig. 25), he went into debt to buy for the sum of £30, became in the mid-1930s a startling exception to this trend.

But it seems likely that it was in Kassel, not in Dublin, that Beckett had his first real encounters with Modernist painting. A number of documents have recently surfaced which reveal that several of the painters whose work 'Boss' Sinclair owned in Kassel have since become world famous and – ironically, in view of the Sinclairs' appalling financial position at the time – three of his paintings would be worth a fortune today. The documents also show that 'Boss' Sinclair was a fervent, well-informed collector and dealer, fully aware of the value of what he possessed as important works of art.

The first of these documents consists of an agreement with a list of the paintings which Sinclair loaned to the Städtische Galerie in Kassel in 1930, with their titles and their insurance valuations (fig. 31). This list, which identifies the modern paintings that Beckett saw in his uncle's collection in Kassel, fortunately survived the heavy bombing of the town during the Second World War.[11] There are, in fact, two such lists, with minor variations, dated 28 July and 15 August 1930 respectively. They represent different stages of the official loan agreement. The second has two paintings fewer than the first, Ewald Dülberg's *Abendmahl* and the second, Max Burchartz's painting, being omitted, perhaps because Sinclair had either sold them or withdrawn them in the meantime. The valuation figure placed on the Boccioni painting has also been increased from 5,000 to 10,000 Marks.

Another (and quite separate, though related) document comes from William Sinclair's son, Morris. It consists of the handwritten script of a lecture on Modern German art which his father gave to the Society of Dublin Painters at No. 7, St Stephen's Green shortly after his return to Ireland in 1933. Quotations in this essay are taken from these sets of documents, as well as from letters from William Sinclair to friends in Dublin.[12]

The lists from the Kassel gallery (both of them) include paintings by the leading Italian Futurist painter, Umberto Boccioni, by Heinrich Campendonk, and by the New York-

born cartoonist, painter and teacher at the Bauhaus, Lyonel Feininger. The other painters and a sculptor on the lists are less well known than the 'big three', but they are still far from negligible. The Köln painter, Josef Kölschbach,[13] and the Darmstadt sculptor, Adam Antes, are little known today, although Antes won the Georg Büchner prize in 1929.[14] But Reinhold Ewald is still rated fairly highly and a collection of his paintings is housed in the Museum at Hanau.[15] The Ewald picture, *Zwei Männer*, owned by Sinclair and called by him 'Comrades', would, he wrote to Seumas O'Sullivan, 'delight alone for its beautiful colouring reminiscent of Manet. [B]ut the worst of the Expressionist he won't leave you there to delight in colour and dream he wakes you up. Whither? Why?'[16] The Bauhaus painter-graphic designer-photographer, Max Burchartz,[17] and Josef Eberz have many admirers and their paintings (and, in Burchartz's case, paintings and photographs) are still exhibited in public collections in Germany and throughout the world. Josef Eberz's painting, *Ruhende Tänzerin vor dumpfer Landschaft* (fig. 32) which was owned by Beckett's uncle, was almost certainly the one reproduced earlier in black and white in Leopold Zahn's 1920 Junge Kunst volume.

Tänzerin in Landschaft ruhend. 1919

Fig. 32: Josef Eberz, *Ruhende Tänzerin vor dumpfer Landschaft* (Resting Dancer in a Hazy Landscape), 1919, oil on canvas, whereabouts unknown

Campendonk, Boccioni and Feininger

A closer look at the three best known painters on Sinclair's list and, when possible, at what Samuel Beckett thought and wrote about them, will help to assess the impact that these and other major modern painters had on the writer and his work.

As a young man, Beckett was fascinated by the German artists of *Die Brücke, Der Blaue Reiter* and the *Bauhaus* movements and 'Boss' Sinclair owned a number of works which belonged to or were associated with these schools. One painter who exhibited in the first *Der Blaue Reiter* exhibition in 1911, and to whom Beckett was introduced through his uncle's collection, was Heinrich Campendonk. The painting which Sinclair owned was one of Campendonk's dream pictures, entitled *Die Einsame* (fig. 33).[18] This picture has disappeared and was probably destroyed in the Nazi *Entartete Kunst* (or Degenerate Art) purge. But it can be identified from a black and white

Fig. 33:
Heinrich Campendonk,
Die Einsame,
(The Lonely One),
probably destroyed
c.1939

photograph in Andrea Firmenich's *catalogue raisonné* on the basis of Sinclair's own description. In his unpublished talk to the Society of Dublin Painters, he waxed lyrical about his Campendonk painting: 'His colours', he said, 'suggest the rich warm dyes of deep piled Persian carpets and the luminosity of Limoges enamel. To have one of his pictures hanging on your walls is to feel the steady glowing embers of a fire that never needs attending to. I have sometimes imagined that in the twilight it actually illumined the room. The blues the reds the golds were flaming steadily and a faint whiff of smoke trails out in the infinite. This picture of a dream. He called it The Lonely One. A shadowy figure brooding among the clouds, thro [through] whose body and around whom [can] be seen dimly cattle and children and dark spaces suggesting woods thro [through] which enchanted horsemen chase'. He concluded that 'the picture is as allusive as a dim remembered dream'.[19]

A letter to Tom MacGreevy from 1935 reveals that Beckett continued to take an interest in Campendonk's work: 'Nancy Sinclair' [another of Sinclair's daughters], he wrote, 'showed me a very nice [book on] Campendonk in the Junge Kunst series.[20] Do you know his work? I only did from one picture the Boss had in Germany. I find it very interesting. But I think you would jib at the German canister'.[21] However, although Beckett alluded to Campendonk later in a comic context in his 1938 novel, *Murphy* (where 'a Hindu polyhistor of dubious caste' had been writing for many years 'a monograph provisionally entitled: *The Pathetic Fallacy from Avercamp to Kampendonk*'[sic]),[22] he probably found the former *Blaue Reiter* painter and friend of Franz Marc too close in style to Marc Chagall (an artist whom Beckett once told me he actively disliked)[23] for him to remain for very long among his favourite painters.

Secondly, a more famous – and happily still extant – picture owned by Sinclair and well-known to Beckett was *Das Lachen* (The Laugh) by Umberto Boccioni (fig. 34). Sinclair wrote to his friend, Seumas O'Sullivan, in October 1924, 'I possess the "Laughter" of Boccioni,'[24] and, in the list of pictures loaned to the Kassel gallery, he wrote – with more pride than accuracy – that it was 'das erste

Fig. 34:
Umberto Boccioni,
The Laugh, 1911,
oil on canvas,
110.2 x 145.4 cm,
Museum of Modern Art,
New York

futuristische Gemälde' ('the first Futurist painting'),[25] dating the painting four years earlier than it was actually painted. Twelve years later, Beckett wrote to MacGreevy from Hamburg that 'Marc's *Mandrill* [in Hamburg's Kunsthalle until 1937, but now in the Pinakothek in Munich] is amusing, but I think, not so good as the Boccioni that Boss Sinclair had in Kassel.'[26] This comment might suggest that Beckett was remembering a Boccioni on the same theme as Franz Marc's *Mandrill*. Boccioni seems, however, not to have painted any picture of a mandrill, and the link was probably made by Beckett on the basis of stylistic rather than thematic similarities.

The Laugh is now a prize exhibit in the Museum of Modern Art in New York with a provenance revealing that it went out of a certain William Sinclair's possession in November 1932, having been offered for sale earlier by him to Benito Mussolini to be purchased for the Italian nation. 'I have the temerity', wrote Sinclair to Mussolini, 'to write to you about the picture *Laughter*, the masterpiece of the father of Futurism Umberto Boccioni. It is difficult to exaggerate either the powerful beauty of this picture or its

importance in the history of art, but circumstances compel me to dispose of my collection – at present on loan in the state gallery here – and I should be glad to know if you or any of the Italian galleries would consider purchasing it. Quite apart from my own necessity I feel this great work should find a resting place in Italy'.[27] His offer was refused laconically by one of Mussolini's officials. [28]

Thirdly, Beckett wrote to Gottfried Büttner in 1986 that the Sinclairs 'had a good Feininger' painting[29] and, in the last year of his life, he told me that he could still remember this picture hanging over the Ibach piano in the Sinclairs' apartment.[30] The painting, executed in 1913 and entitled *Badende I* (fig. 35),[31] was one of which Lyonel Feininger himself was especially fond. As he was painting it, he wrote to his wife, Julia, that 'it will be a strange picture and, I believe, very beautiful. But melancholy and sombre'.[32] A few days earlier, he had described it as 'nether worldly and monumental'.[33] When the Sinclairs were obliged to leave Kassel in 1933, this canvas may well have been sold at auction, but, if it survived the later Nazi purge of degenerate art, which is doubtful, its whereabouts have

Fig. 35: Lyonel Feininger, *Badende I* (The Bathers), 1913, probably destroyed c.1939.

still to be established. A black and white photographic reproduction in the *catalogue raisonné* reveals, however, that it was, in Hans Hesse's words, a 'calm, rectangular composition of broad solid planes, divided equally between the sea and sky, with sailing boats on the one hand and land and people on the other'.[34] Beckett would certainly have remembered this picture and he sought out a lot of Feininger's work during his later German tour.

Ewald Dülberg's *Abendmahl*

It is, however, a picture by one of the less famous artists that reveals most about Beckett's early responses to German Expressionist art. He evoked one of his uncle's most striking and cherished paintings by Ewald Dülberg, the *Abendmahl* (fig. 36), directly in both his early poem, *Casket of Pralinen for the Daughter of a Dissipated Mandarin* and in his 1930-32 novel, posthumously published, *Dream of Fair to Middling Women*.[35] Since this painting was among those destroyed by the Nazis, we know the work only from a tattered sepia photograph.[36] A woodcut on the same subject has survived.[37] Another version of the woodcut, acquired by the Hamburger Kunsthalle in 1917, was destroyed with the painting in 1939. According to Sinclair's son, Morris, his father also owned another large woodcut of Dülberg.[38]

Ewald Dülberg (1888-1933), who taught for a number of years at Kassel's Staatliche Kunstakademie from 1921, had been more or less forgotten until recently. Yet, as well as being a very talented painter, he was a highly innovative stage designer whose radical thinking about stage space and monumental, Cubist-style stage-sets for operas like *Fidelio*, *Oedipus Rex* or *The Flying Dutchman* strongly influenced Otto Klemperer. Dülberg was a personal friend of William Sinclair and a regular visitor at No. 5, Landgrafenstrasse. He died of tuberculosis in 1933, the same year that (whether coincidentally or not) Sinclair's daughter and Beckett's early love, Peggy, died of the same disease.

In the *Abendmahl* painting, Christ's apostles are depicted as bald, flattened, seemingly superimposed eggheads and it was Dülberg's strikingly bold Expressionistic manner of treating this traditional religious subject which Beckett

Fig. 36:
Ewald Dülberg,
Das Abendmahl
(The Last Supper),
destroyed c.1939

echoed in *Dream of Fair to Middling Women*: 'He [Belacqua] goggled like a fool at the shrieking paullo-post-Expression of the Last Supper hanging on the wall fornenst him, livid in the restless yellow light, its thirteen flattened flagrant egg-heads gathered round the tempter and his sop and the traitor and his bourse. The tempter and the traitor and the Jugendbund of eleven. John the Divine was the green egg at the head of the board. What a charming undershot purity of expression to be sure! He would ask for a toad to eat in a minute'.[39]

Sinclair had described the Dülberg painting earlier in a letter to Seumas O'Sullivan in the following words: 'The attempt here is not to arrange with virtuosity, with observation of detail and cleverness of the dead art schools but with flowing full colour harmonies to suggest something of the wonder of the forgotten faith, whose weary shadow still deludes the world though the subject the people the message remain for ever beautiful and true. The colours are those of ancient Chinese porcelain and have almost the same brilliancy. It is painted in the manner of the old masters, that is in glazes on wood'.[40] In his talk to the Society of Dublin Painters, Sinclair went further, describing it as 'of all the pictures I saw the one that delighted and surprised me the most. I first saw it in a public exhibition where it hung for 6 weeks. The local newspaper critics had all abused the picture in the most violent manner and I only found one art journal which gave it a favourable notice. Someone had actually slashed it with some weapon but as the picture was painted on wood, no great damage was done'.[41]

Beckett and German Expressionism

So much for what Beckett saw of modern German and Italian art in his uncle's collection in Kassel. The more interesting and important question, however, is whether these paintings had any particular impact on Beckett and, taken along with later Expressionist paintings that he knew, whether they influenced him in any way in his own later writing or his stage imagery? Discussion of such a relationship can only remain, of course, at the level of surmise. However, until 1928, Beckett's experience of painting had been more or less confined to the work of the Old Masters in the National Gallery of Ireland (with the occasional more modern exhibition at Dublin's Municipal Gallery) and in Florence and Venice, both of which he visited in the summer of 1927. And it is worth stressing that his first encounters with modern German painting were made at an impressionable age, even before he saw himself becoming a writer. The durability and the sharpness of his memories of some of Sinclair's 'large collection of mad pictures', taken along with his early poetic and fictional responses to Dülberg's *Abendmahl*, suggest that they came as a revelation and inspired his curiosity about modern German art. He built upon this during a six month stay

in Germany in 1936-37, when he was willing to rearrange his schedule if he learned that there was an important collection of modern German paintings to be seen. His uncle's collection in Kassel was also large enough and eclectic enough to reveal to Beckett the diversity of styles that characterised various movements in modern German art. We should also remember that for most of the period when he was visiting the Sinclairs during the holidays, he was living in Paris, working as a *lecteur d'anglais* at the École Normale Supérieure. Consequently he was able to visit modern art exhibitions there, often in the company of the knowledgeable Tom MacGreevy, who took a keen interest in modern French art and who had written enthusiastically about Picasso and the Cubist-inspired pictures of Mainie Jellett, the Irish painter mentioned earlier, several years before he ever met Beckett.[42]

More significantly, however, Beckett would have absorbed from his uncle a view of modern German art that concentrated more on the *angst* to which some of these painters gave expression than on the earlier idealistic strivings for a better society of *Die Brücke* group. In a letter to Seumas O'Sullivan of 1923, William Sinclair offered the kind of view of German Expressionist art that he would certainly have communicated to Beckett a few years later. 'I don't think I can write about modern German art. It is too big for me[;] it's too close to life. The German artist today tries to achieve not what the eye, the camera or the kino [does] but what he imagines God sees. He has not the peace of the pre-Raphaelites or the Ivy of the Renaissance, the poetry of the Impressionists or the logic of the post-Impressionists. He is lost lingering in horror and wonder at the world he finds himself in. The breasts of women are still wonderful and the birth of a baby miraculous as the stars. But he has had years of horror and starvation. He questions the whole sorry stupendous scheme. His hands which were made for shaping hymns have been torn with barbed wire and maimed, shattered in every conceivable way. His soul has been more tortured and so his painting is a plaint'.[43] Beckett was much more intellectual and more sophisticated in his approach to art than the emotional, instinctive 'Boss' Sinclair ever was. Yet his use of words like 'shrieking', 'livid' and 'restless' in connection with Dülberg's *Abendmahl*

suggests that the elements emphasised by his uncle were at least part of his own response to that Expressionist artist's work.

It would be artificial, however, to separate these early encounters with Expressionist art from Beckett's later experiences in Germany. The painters to whose work he responded most enthusiastically during his 1936-37 visit (Edvard Munch, Emil Nolde, Ernst Ludwig Kirchner and, to a lesser extent, Karl Schmidt-Rottluff) could be said to be broadly definable by such an anguished view of human existence as his uncle described, although the diversity and range of their painting cannot be limited by such a view.

Much has been made – understandably enough – of the resemblances between Edvard Munch's painting of *The Scream* and Mouth's scream in *Not I* or even May's anguish in *Footfalls.* In fact, one of the clarifications that a detailed study of Beckett's German diaries will provide will be to reveal how much he admired the paintings of Munch that he saw during his visits to the German public galleries or private collections. His interest was not confined, however, to Munch's more *angst*-ridden paintings. After his visit to Hudtwalcker's private collection on the Elbchaussee in Hamburg, for instance, he described the *Three Women on a Bridge* (a very different painting in subject and tone from *The Scream*), now in the Hamburger Kunsthalle, as 'a superb Munch, three women on a bridge over dark water, apparently a frequent motiv. Best Munch I have seen'.[44]

Reading his German diaries, one has the impression that Beckett was still making discoveries at that stage about Expressionist painters like Nolde, Schmidt-Rottluff and Kirchner, let alone Heckel, Pechstein and Müller.[45] Beckett's interest in the work of Emil Nolde, for instance, seems to have been stimulated by the latter's deep unpopularity with the Nazi regime, for, in spite of his own early support for National Socialist principles, Nolde suffered more than any other German artist in the purge of public galleries, when more than a thousand of his works were confiscated. While visiting the Durrieus, Beckett learned that Nolde's autobiography, *Das eigene Leben*, was about to be banned: 'i.e. buy Nolde quick', he wrote in his diary, which he promptly did the following day.[46] His admiration for Nolde's *Christus und die Kinder*

then in the Hamburger Kunsthalle is by now well-known: 'Feel at once on terms with the picture, and that I want to spend a long time before it and play it over and over again like the record of a quartet', he wrote in his diary.[47] Less familiar are his reactions to the Nolde paintings in what was called the *Schreckenskammer* (Chamber of Horrors) in Halle, a permanent exhibition of 'degenerate art' which he visited on 23 January 1937. 'Harem[s]wächter. Diener [attendant] sneers at work in Eunuch's head / Judas before High Priests - a dreadful caricature of the Sheeny [the Jew] that pleases the Diener. How is such a conception possible? The expression of Nolde's miserable thinking. Shouldn't be painting anything but Nature /. Abendmahl. Interesting composition and wonderful painting. Light of faith pouring from Kelch'.[48] Yet with Munch, Nolde and – even more strongly – with Schmidt-Rottluff, Beckett had reservations which centered upon issues of sentimentality and the overstated. However lovely he found Munch's *'Einsamkeit'*, for example, he wrote in his diary: 'even here the feeling inclined to be overstated into the sentimental …What is it in this uncompromising Norderin (Nolde and Hamsun also) that always threatens to upset the whole apple cart'.[49]

Although he took a keen interest in Karl Schmidt-Rottluff's painting, with which the art historian and collector Dr Rosa Schapire was besotted,[50] and although, selectively, he admired some of Schmidt-Rottluff's individual paintings, there was, nonetheless, a monumentalism and a grandiloquence about his work that Beckett rejected.

The one Expressionist painter who totally escaped the criticisms of the sentimental, the monumental and the overstated was Ernst Ludwig Kirchner. Having admired Kirchner's drawings in Hamburg for their 'incredible freedom and finality',[51] he compared his work later in Berlin with that of Schmidt-Rottluff, commenting 'I find Kirchner a purer artist, incredible line and sureness of taste and fineness of colour'.[52] He described Kirchner's *Im Cafégarten* or *Damen im Café* of 1914, which he saw in Halle, as 'charming'.[53] Visiting the eminent art historian and former director of the Zwinger Gallery in Dresden, Willi Grohmann, who was the first to publish a serious study of Kirchner's work, he was delighted to learn that

'[Grohmann] agrees that Kirchner is the most important artist of [Die] Brücke and that the monumentality of Schmidt-Rottluff [is] often voulue [deliberate].'[54]

That Beckett felt very strongly about the entire campaign that was currently being waged against Expressionist art and artists by the Nazis in 1936-37 is shown by the vehemence of his reactions when he read in a Berlin newspaper about what he called 'the bloody new Glaspalast in Munich, Haus der deutschen Kunst and the coming exhibition open to high and low, all and sundry. Now that the period of Nolde, the Brücke, Marc etc has been überwunden [i.e. has run its course]. Soon I shall really begin to puke. Or go home'.[55]

Influence and recognition

It is tempting to see certain specific Expressionist or Cubist techniques − unusual perspectives, distortion, isolation and fragmentation, for example − as actual influences on Beckett when he created his own later stage images. This may well be true, although it can probably only be suggested rather than proven.

One example relates to the issue of viewpoint and perspective. While showing Beckett Lyonel Feininger's paintings in the Halle *Schreckenskammer*, the attendant escorting him around poured scorn on what he regarded as the distorted, non-naturalistic features of Feininger's paintings. Beckett wrote in his diary that the 'Diener is troubled by some perspectives that are not alas in nature'.[56] He himself was totally untroubled by the perspectives that he saw operating in the *Marienkirche mit dem Pfeil* or *Der Turm über der Stadt*, which were painted during Feininger's 1930-31 stay in the Moritzburg Tower in Halle, choosing instead to focus on and distinguish between early and late Feininger styles. The Halle paintings, he wrote, are 'all about 1930 and technique less interesting than the out and out "plane" technique of earlier Feininger, of which some examples here also'.[57] A similarly unusual, partly aerial, perspective is also adopted in a work like Ernst Ludwig Kirchner's *Der rote Turm von Halle* of 1915, now in Essen.

When, many years later, Beckett came to create startling images for his own late plays, he introduced a number of unusual perspectives of his own: Mouth is installed,

Fig. 37:
Wolfskehlmeister,
*Tombstone of Bishop
Otto von Wolfskehl*,
c. 1348, Würzburg
Cathedral

Fig. 38:
Wolfskehlmeister,
*Tomb of Bishop Friedrich
von Hohenlohe*, c. 1352,
Bamberg Cathedral

for example, 'about 8 feet above stage level' in the stage darkness; Listener's head in *That Time* is described 'as if seen from above'; the table at which two figures sit in *Ohio Impromptu* is set on an incline. (Kirchner's treatment of the figure at a table in *Self Portrait as a Drinker* from 1916, now in the Germanisches Museum in Nuremberg, provides, incidentally, an interesting point of comparison with this latter play.)

Yet with a creative mind like that of Beckett, influence is simply too straightforward and too deterministic a concept to be very helpful. Instead, *recognition* – of affinities and resemblances – is much more appropriate to the ambiguity, subtlety and suggestiveness of his artistic world, as well as to the diversity and complexity of what we know to have been his multifarious sources of inspiration in the much better charted area of literature.

Beckett never had any problem in relating the works of art of previous centuries as well as those of his own era to his thinking about literature and the theatre. When he visited Bamberg and Würzburg in February 1937, for example, he was drawn back on a number of occasions to the medieval statues which had been executed by the sculptor known as the 'Wolfskehl Meister', so called after his tombstone of Otto von Wolfskehl in Würzburg Cathedral (fig. 37). As Beckett looked at another statue by the same hand in the Bamberger Dom (fig. 38), he wrote in his diary that the 'Wolfskehl Meister' was the "Master of [the] senile & [the] collapsed. Another man for me. Remember: "WOLFSKEHL-MEISTER".[58] In other words, he recognised in these statues something that resonated in or even belonged to his own inner world.

This experience recalls other moments of what could be described as 'thrilled illumination' in the German diaries. One of the most striking of these is to be found in his recognition in Karl Ballmer's painting (fig. 39) of elements that were common to his own view of the world of representation. 'Wonderful red Frauenkopf, skull earth sea and sky, I think of Monadologie and my Vulture [i.e. his poem with that title]. Would not occur to me to call this painting abstract. A metaphysical concrete. Nor Nature convention, but its source, fountain of Erscheinung. Fully a posteriori painting. Object not exploited to illustrate

an idea, as in say Léger or Baumeister, but primary. The communication exhausted by the optical experience that is its motive and content. Anything further is by the way. Thus Leibniz, monadologie, Vulture, are by the way. Extraordinary stillness'.[59]

Beckett visited the studios of a number of Hamburg painters at the end of November 1936. In writing about these meetings in his diary, he made a revealing comparison between the painting of Edouard Bargheer and that of Karl Ballmer and Willem Grimm, which he much preferred: 'his [Bargheer's] painting of enormous competence and earnestness, yet he and his painting say nothing to me. It is the bull of painting by the horns. Prefer the stillness and the unsaid of Grimm and Ballmer'.[60] And talking of the work of Bargheer and Kluth on the one hand and Ballmer and Grimm on the other, Beckett wrote that there were 'Violent painters and calm painters'. Then he added the comment, 'Better: painters of violence and calm'.[61] This last remark is very revealing and seems apposite to the relationship that existed between Beckett's own theatrical world and modern German painting. *Endgame*, *Play*, *Not I*, *Footfalls*, even *Rockaby*, display an *angst*, even at times a violence, that has much in common with the work of painters like Munch, Kirchner, or even Dix – one thinks of the figures rattling out their venom from their funeral urns in *Play*, of Mouth's screams, or of the verbal phrase, 'Fuck life', tossed casually into a lullaby which seems to be leading its speaker/singer gently into death. Yet there is also a counter tendency in Beckett's plays that is akin to the stillness that he recognised in the paintings of Ballmer and Grimm. A vital impulse in his own work appears indeed to have been that of integrating the 'extraordinary stillness' and the 'unsaid' with the violence of *The Scream*. These different, even contrasting elements are fundamental to his efforts as a writer to express 'being'.

Beckett and Jack B. Yeats

Beckett's passionate appreciation of Jack B. Yeats' later painting stemmed from a highly personal interpretation with which his friend MacGreevy seems to have disagreed[62] and from which Yeats himself might well also have disassociated himself. Beckett discovered apartness,

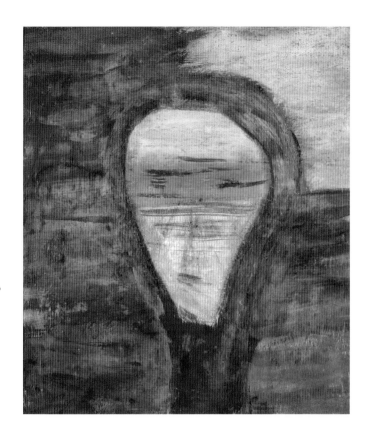

Fig. 39: Karl Ballmer, *Kopf in Rot*, 1930/31, oil on canvas, 67 x 59.5 cm, Aargauer Kunsthaus, Aarau

Fig. 40: Jack B. Yeats,
A Storm, 1936,
oil on canvas,
46 x 61 cm,
private collection

solitude, isolation and alienation in Yeats' 1930s paintings, while MacGreevy saw in him 'the first great Irish painter'. In a letter to MacGreevy of 1937, Beckett wrote: 'I find something terrifying for example in the way Yeats puts down a man's head and a woman's head side by side, or face to face, the awful acceptance of 2 entities that will never mingle. And do you remember the picture of a man sitting under a fuschia hedge, reading, with his back turned to the sea and the thunder clouds? (fig. 40) One does not realise how still his pictures are till one looks at others, almost petrified, a sudden suspension of the performance, of the convention of sympathy and empathy, meeting and parting, joy and sorrow'.[63] Writing in a letter to Georges Duthuit many years later of his continued admiration for Jack Yeats' work,[64] Beckett admitted that when he talked about art, he was invariably expressing his own obsessions: his own bleak, uncompromising vision of human separateness and loneliness. This vision was already present in his 1931 study of Proust, when he wrote elliptically: 'We are alone. We cannot know and we cannot be known'.[65] Alienation of all kinds was to become

a constant in Beckett's theatre: alienation from the world; alienation from the other; alienation from the self.

If his uncle's Ewald Dülberg painting simply offered to the young Beckett a surface allusion, the visual equivalent of a quotation from Burton's *Anatomy of Melancholy*, his subsequent experiences of the work of Yeats, Munch, Kirchner, Ballmer and Grimm were to be absorbed and assimilated at a much deeper level into his own later work. These painters each probably brought something different to Beckett's approach to art and literature. But they provided him above all with a confirmation of different aspects of his own vision. We can say then, with confidence, that he discovered in German Expressionist art, as well as in the painting of his Irish friend, Jack Yeats, what he wanted to find there.

1 For a fuller discussion of Beckett's relations with the Sinclairs and his affair with his cousin Peggy, see James Knowlson, *Damned to Fame. The Life of Samuel Beckett* (Bloomsbury, London, 1996).

2 'My art collection has always been in the Museum but mostly not on view as one of the directors is anti-modern. The other is my friend and so thank God, I have free storage for my collection, more fearful than Phelan Gibb [Irish artist, 1870-1948] of delirious memory'. Letter from William Sinclair to Seumas O'Sullivan, 9 October 1924, TCD MS 4632/623

3 Letter from William Sinclair to Miss E. F. [Estella] Solomons, 4 April 1925, TCD MS 4632/640

4 Letter from Samuel Beckett to Thomas MacGreevy, 12 December 1932, TCD MS 10402

5 Letter from Samuel Beckett to Thomas MacGreevy, 5 January [1933], TCD MS 10402

6 On occasion, Sinclair and his wife had literally nothing to spend, not even the money to buy a stamp or pay for a bus-fare: 'Today we have not one pfennig. Not one little 2 3 four five or even ten pfenning bit'. Letter from William Sinclair to Miss E. F. [Estella] Solomons, 4 April 1925, TCD MS 4632/640. His wife, Beckett's aunt Cissie, also wrote from their holiday by the seaside: 'Oh! God it's a beastly nuisance being so hard up. My little nestegg is all spent and now we are on the rocks again. It will take us all our time to scrape up enough for our return tickets! And when we get to C[K]assel I don't know what we'll do.' Letter from Cissie Sinclair to Estella Solomons, 30 July 1926, TCD MS 4633

7 Karl Leyhausen (1899-1931) was a local Kassel painter. See *Gedächtnis Ausstellung Karl Leyhausen (1899-1931)* (Ausstellungshefte der Städtischen Kunstsammlungen zu Kassel, Kassel, 1952) and *Karl Leyhausen 1899-1931* (Bärenreiter, Kassel, 1982).

8 Samuel Beckett, *Dream of Fair to Middling Women* (The Black Cat Press, Dublin, 1992), p. 4. This painting of Sinclair's daughter is owned by the estate of the late Dr Gottfried Büttner and is still in Kassel.

9 S. B. Kennedy, *Irish Art and Modernism* (Institute of Irish Studies, The Queen's University of Belfast, 1991), p. 34

10 Letter from Samuel Beckett to Thomas MacGreevy, 20 December 1931, TCD MS 10402

11 I am most grateful to Christel Hollervoet-Force from the Museum of Modern Art in New York for news of this discovery and to her and Dr Marianne Heinz from the Städtische Galerie in Kassel for help in obtaining copies of these documents.

12 I am most grateful to Dr Marianne Heinz of the Staatlichen Kunstsammlungen in Kassel and to William Sinclair's son, Morris, for permission to publish these documents and to Dr Bernard Meehan and the Board of Trinity College, Dublin, Library for the quotations from Sinclair's letters to Estella Solomons and Seumas O'Sullivan.

13 William Sinclair owned two paintings by the Köln painter, Josef Kölschbach: *Konversation* and *Weiter Innnerraum*. Kölschbach (1892-1947) is referred to in Robert Steimel, *Kölner Köpfer* (Steimel, Köln, 1958) as a painter of landscapes and interiors.

14 In the list of winners of the Georg Büchner Prize from 1923-2002, we find the sculptor Adam Antes from Darmstadt listed as having won the prize in 1929, along with Karl Zuckmayer. Sinclair owned Antes' sculpture *Frauentorso, rote Terrakotta*.

15 The Museum in Hanau owns a number of fine paintings by Reinhold Ewald (1890-1974) including *Das Karussell* (1919) and *Zwei Mädchen* (1921). The painting owned by Sinclair, *Zwei Männer*, is not, however, among them.

16 Letter from William Sinclair to Seumas O'Sullivan, 9 October 1924, TCD MS 4632/623

17 Sinclair had two paintings by Max Burchartz (1887-1961). These were a *Damenbildnis vor blauem Hintergrund* and a *Mädchen in grünen Kleid beim Haarkämmen*.

18 The whereabouts of Campendonk's painting, *Die Einsame* (1919), is currently unknown. It is reproduced from a photograph in Andrea Firmenich's *Heinrich Campendonk 1889-1957 Leben und expressionistisches Werk mit Werkkatalog der malerischen Oeuvres* (Verlag Aurel Bongers, Recklinghausen, no. 793). The reproduction there clearly conforms to Sinclair's brief account of it in his talk to the Society of Dublin Painters. However, in the August 1930 list of his paintings loaned to the gallery, a Campendonk valued at 600 Marks is entitled *Waldvision*. This may well be the same painting with a different name or a quite different one which Sinclair owned but which has also not been preserved. Considering the very slight time difference between the two lists, it is, however, almost certainly the same.

19 Unpublished talk by William Sinclair given 'at the rooms of the Society of Dublin Painters in [7] St. Stephens Green' shortly after the Sinclairs had returned to Dublin from Kassel in 1933. Courtesy of William Sinclair's son, Morris.

20 The book referred to here by Beckett in the *Junge Kunst* series (vol. 17) was Georg Biermann's *Heinrich Campendonk* (Klinkhardt and Biermann, Leipzig, 1921). It has a coloured frontispiece and 52 black and white illustrations, as well as an introduction and a short biography of the artist.

21 Letter from Samuel Beckett to Thomas MacGreevy, 1 January 1935, TCD MS 10402

22 Samuel Beckett, *Murphy* [1938] (Grove Press, New York, 1957), p. 196

23 Samuel Beckett, conversation with James Knowlson, July 1989

24 Letter from William Sinclair to Seumas O'Sullivan, 9 October 1924, TCD MS 4632/623

25 List preserved at the Staatlichen Kunstsammlungen, 28 July 1930

26 Letter from Samuel Beckett to Thomas MacGreevy, 9 October 1936, TCD MS 10402

27 I am again grateful to Christel Hollevoet-Force of the MOMA for her help with details of the provenance of this picture. The Museum of Modern Art records show that *La Risata* (The Laugh), as it is now known, was once owned by Albert Borchardt, then by 'William A. Sinclair (art-dealer), Kassel' until Karl Beierling acquired it on 27 November 1932. It was then acquired in the mid-1950s by Herbert and Nanette Rothschild and donated by them to the Museum of Modern Art in New York in 1959.

28 The Museum of Modern Art had no idea until they were informed recently by myself that the previous owner, William Sinclair – one of only four to own the work since it was painted in 1911 – was Samuel Beckett's uncle, or indeed that Beckett not only knew the painting but alluded to it in his correspondence. This information has now been incorporated into the notes on the provenance.

29 Letter from Samuel Beckett to Gottfried Buttner, 5 July 1986 (private collection)

30 Samuel Beckett, interview with James Knowlson, c. July 1989

31 On William Sinclair's list, this Feininger painting was entitled *Badende an der See* and it was the second highest insurance valuation – next to the Boccioni – at 3,500 Marks.

32 Letter from Lyonel Feiniger to Julia Feininger, 26 August 1913

33 Letter from Lyonel Feiniger to Julia Feininger, 21 August 1913

34 Hans Hess, *Lyonel Feininger* (Harry N. Abrams, Inc., New York, 1961), p. 66

35 Samuel Beckett, *Dream of Fair to Middling Women* (The Black Cat Press, Dublin, 1992)

36 When Beckett met Ewald Dülberg's son, Peter, in Hamburg in November 1936, Dülberg told him that he did not know where the *Abendmahl* was. (Samuel Beckett, *German Diaries*, vol. 2, 22 November 1936). Strangely it was in the Hamburger Kunsthalle and, at the moment, we do not know why he did not see it there. Beckett did not like the son's own painting: 'Horrid pictures, father's world sentimentalised and in symbols, Zuckerkrake Bilder, wimmernde Farben, influence of Dali'. (Samuel Beckett, *German Diaries*, vol. 2, 16 November 1936).

37 Maike Bruhns informs me that her copy (which may be the only surviving one) came from the estate of Hedwig Arnheim, the second wife of Ewald Dülberg. The woodcut which was in the Hamburger Kunsthalle was destroyed in 1939, two years after its confiscation in the *Entartete Kunst* (Degenerate Art) action. Maike Bruhns, e-mail to James Knowlson, 13 February 2004

38 Letter from Morris Sinclair to James Knowlson, 17 February 2004

39 Beckett, *Dream of Fair to Middling Women*, 1992, p. 77

40 Letter from William Sinclair to Seumas O'Sullivan, 9 October 1924, TCD MS 4632/623

41 William Sinclair, Unpublished talk to the Society of Dublin Painters.

42 Thomas MacGreevy, 'Picasso, Mamie [error for Mainie] Jellett and Art Criticism', *The Klaxon*, vol. 1, no. 1 (Winter 1923-24), pp. 23-27

43 Letter from William Sinclair to Seumas O'Sullivan, 9 October 1924, TCD MS 4632/623

44 *German Diaries*, vol. 2, 22 November 1936

45 In the bedroom of the lavish apartment of the collector Hudtwalcker in Hamburg, Beckett saw 'a magnificent Otto Müller (man and woman), very Brückisch (he was a member, as I knew not)'. *German Diaries*, vol. 2, 22 November 1936

46 *German Diaries*, vol. 2, 11 November 1936

47 *German Diaries*, vol. 2, 19 November 1936

48 *German Diaries*, vol. 4, 23 January 1937

49 *German Diaries*, vol. 4, 20 January 1937

50 *German Diaries*, vol. 2, 14 November1936. Beckett first met Dr Rosa Schapire in Hamburg. Her 'Wohnung' [sitting-room], wrote Beckett in his diary, was 'full of Schmidt-Rottluff, whom she holds to be genius of the century'.

51 *German Diaries*, vol. 2, 19 November 1936

52 *German Diaries*, vol. 3, 19 December 1936

53 *German Diaries*, vol. 4, 23 January 1937. This painting is now in the Brücke Museum in Berlin.

54 *German Diaries*, vol. 4, 2 February 1937

55 *German Diaries*, vol. 4, 15 January 1937

56 *German Diaries*, vol 4, 23 January 1937

57 *ibid.*

58 *German Diaries*, vol. 5, 25 February 1937

59 *German Diaries*, vol. 2, 26 November 1936

60 *ibid.*

61 *ibid.*

62 Samuel Beckett, 'MacGreevy on Yeats', *Irish Times*, 4 August 1945, reprinted in *Disjecta. Miscellaneous Writings and a Dramatic Fragment* (ed. Ruby Cohn) (John Calder, London 1983), pp. 95-97

63 Letter from Samuel Beckett to Thomas MacGreevy, 14 August 1937, TCD MS 10402. The painting to which Beckett is referring here is *The Storm*, painted in 1936.

64 Letter from Samuel Beckett to Georges Duthuit, 2 March 1954, (Claude Duthuit).

65 Samuel Beckett, *Proust and Three Dialogues with Georges Duthuit* (Calder and Boyars, London, 1970), p. 66

The 'beyonds of vision': Beckett on art and artists

Lois Oppenheim

In a tribute to Jack B. Yeats written for a 1954 Paris exhibition of the painter's works, Beckett wrote, 'In images of such breathless immediacy as these there is no occasion, no time given, no room left, for the lenitive of comment. None in this impetus of need that scatters them loose to the beyonds of vision'.[1] How utterly obscure! How utterly Beckettian! How utterly characteristic of this writer's extraordinary intellect!

In fact, this enigmatic remark says much about Beckett's thinking on art and the reasons for his preference for certain artists over others. It renders the deepest sort of homage in bearing witness to the self-sufficiency of an art needing no explication or commentary; it attests to the imperative that is creative drive; and it articulates what Beckett held dearest in the making of visual imagery – the abstraction of the visible from within its veil of invisibility. Or is it the reverse – the abstraction of the invisible from its veil of visibility? Such is the difficulty in thinking about Beckett and visual art. Such is the pleasure.

Why, for Beckett, did the legitimacy of Yeats' work, and, in fact, that of any artist he admired, reside in the work's *resistance* to critical commentary? What is the 'impetus of need', the forces that drive the artist? And just how does the painter succeed in rendering on the canvas the primacy of vision or, more accurately, the looking that takes us to the 'beyonds' of what we see? It is in exploring such questions, or so it seems to me, that an understanding of Beckett's relationship to visual art is to be found.

Beckett eschewed the seemingly presumptuous task of the 'crritic', as he famously parodied the interpreter of art in *Waiting for Godot*: 'Moron!', 'Vermin!', 'Abortion!', 'Morpion!', 'Sewer-rat!', 'Curate!', 'Cretin!' – and, finally, 'Crritic!' – are the abuses that play's singular characters launch at each other as they strive to pass the time that, had they made no such effort, would have passed all too reliably.[2] Yet, the literary corpus of one of the twentieth century's most extraordinary playwright/novelists itself contains critical investigations so rich that they definitively debunk his own debunking of critical inquiry. Most of Beckett's art criticism (he also wrote eloquently on literature) was composed between 1945 and 1954. The major texts are 'MacGreevy on Yeats' (1945), 'La peinture

des van Velde ou le Monde et le Pantalon' (1946), 'Peintres de l'Empêchement' (1948), 'Three Dialogues With Georges Duthuit' (1949), 'Henri Hayden, homme-peintre' (1955), and 'Hommage à Jack B. Yeats', the text cited above. During these years Beckett also translated a number of important texts on painting. To make ends meet he translated material for nearly every issue of the magazine known as *transition* between 1948 and 1953. It was not economic need alone, however, that prompted Beckett's entry into the art world. As he made clear on several occasions, his critical writing was motivated, in part, by the desire to do right by his artist friends: 'There is at least this to be said … for art-criticism, that it can lift from the eyes, before *rigor vitae* sets in, some of the weight of congenital prejudice'.[3] Beckett-the-critic was thus Beckett-the-protector, for in writing of art he admired he was protecting admired artist-friends from the biases of the uninformed.

Yet, while many of Beckett's friendships with painters and the impulse to lend a few a helping hand by way of his critical acumen and increasingly celebrated name prompted several of Beckett's forays into criticism, that is hardly the whole story. He collected art rather seriously because he liked it.[4] And he wrote about art, at least in some measure, to dispel the fundamental myth that art needed criticism to *do* something for it. In other words, he wrote about painting to help bring attention to the artist; but he also wrote to reiterate the idea that good art, legitimate art, was irrelevant to critical commentary. In fact, he actually spoke little of any particular paintings under review. Most often, his criticism was but a pretext to articulate a rather extraordinary logic: visual art, he reasoned, could not be written about as there really is no such thing, generically speaking, as visual art. What exists are individual art works and these defy the notion of an objective frame of reference, of the basis for a standard of judgment. 'There is no painting. There are only paintings', he wrote in 'La peinture des van Velde'. 'These, not being sausages, are neither good nor bad. All we can say about them is that they translate, to a greater or lesser degree, absurd and mysterious thrusts toward the image, that they are more or less equivalent to obscure inner tensions'. Just how equivalent is not for the viewer to decide.

Fig. 41: Bram van Velde,
Untitled, 1936/1941,
gouache on card,
125.8 x 75.8 cm,
Centre National d'Art
Contemporain Georges
Pompidou, Paris

Even the painter knows little, if anything, of how successfully these tensions have been transcribed.[5]

Not only is the lack of a standard for judgment what impedes the critic in his endeavour to write about art. The task of the critic is also hampered by the artist's own difficulty of expression, a preoccupation that pervades all Beckett's writing, both critical and creative. Inevitably, the artist must fail at what he does, for the legitimate rendering of reality, of our being-in-the-world (of what Beckett called 'the issueless predicament of existence') is all but impossible.[6] But here is the rub: art that is good – favoured, that is, by Beckett for the artist's ability to face *in the art work itself* the impossibility of any true representation – is all the more impervious to critical attempts precisely by virtue of its worth. Painting cannot be judged as good or not good, yet the better the art the more impervious it is to critical commentary. The paradox is stunning!

Let's put it another way: as it was for Sisyphus who rolls his rock up the mountain doggedly pursuing success in full awareness of the inevitability of failure, dignity for the artist lies in the conscious effort to paint what cannot be painted. Painting, like music, can come close to breaking the code of aesthetic failure, as Yeats did in producing images that are loosened on the 'beyonds of vision' – or on the 'void at the center of sight', as Peggy Phelan has astutely described them.[7] But, it cannot entirely succeed. And literature is an even more difficult nut to crack. Indeed, Beckett's frustration before the dilemma of the writer trying to get beyond the materiality of the word is poignant: 'Is there any reason why', he famously wrote to an acquaintance, 'that terrible materiality of the word surface should not be capable of being dissolved, like for example the sound surface, torn by enormous pauses, of Beethoven's seventh symphony, so that through whole pages we can perceive nothing but a path of sounds suspended in giddy heights, linking unfathomable abysses of silence?'[8]

So who were those who succeeded in failing better than most? And what impelled their Sisyphus-like effort? Certainly, Bram van Velde (fig. 41) came closest for Beckett to the ideal of coping, within his art, with the

un-representational dimension of the world. Jack Yeats and, later, Avigdor Arikha were also praised for their irrepressible drive to represent and their aesthetic solutions to the problem of figuring the un-figurable. But others as well are known to have had special meaning for Beckett: Rembrandt, Caravaggio, Adam Elsheimer, and Gerrit van Honthorst among the Old Masters; Ernst Ludwig Kirchner, Emil Nolde, and others associated with the Die Brücke group; Paul Klee, Lyonel Feininger, Wassily Kandinsky, and other German Expressionists;[9] and Georges Braque, Karl Ballmer, Geer van Velde, and other twentieth-century favourites.

I have explored elsewhere the pictorial inspiration of some of these artists for Beckett's writings.[10] What interests me here, however, is not how Beckett's verbally-expressed visual images reflect stimulation by this or that painting, but his determination that writing on art, whether his own or others', was fundamentally irrelevant to, and indeed a falsification of, the validity of the visual art.

It is not that painting is entirely autonomous; on the contrary, it is nothing without the perceptual animation of viewer. He is most clear about this in 'La peinture des van Velde', Beckett's first published work in French, which appeared in *Cahiers d'art* just after the Second World War. The most important of his writings on the Dutch van Velde brothers, this essay offers clear evidence of Beckett's denial of both the autonomy of painting and the validity of aesthetic judgment. A second essay on the van Veldes, 'Peintres de l'Empêchement' (commissioned by *Derrière le Miroir* for publication in 1948), confirms the writer's a-critical purpose.

Not only, moreover, is the viewer's perception required for the activation of the work beyond its meaning-less objective status, but it is the dialectical interplay operative within the act of viewing, an interplay between the visible and the invisible, that prevents us from conceiving of art generically and thereby judging it. Indeed, the work of the artist and of the viewer resides in the looking as well as the seeing. As Peggy Phelan has so rightly noted, in his own creative project 'Beckett dramatized the rhythm of looking …' This rhythm, with which painters, by the very nature of their craft, are necessarily intimate, 'oscillates between seeing and blindness, between figuration and abstraction, between the void at the center of sight and the contour of the slender ridge that brooks it'.[11] If this was Beckett's preoccupation in his plays and novels, it is also what he most appreciated in visual art. Thus David Lloyd could remark with regard to Beckett's writing on Yeats that 'any notion that Yeats' paintings might represent a doorway between inner truth and outer reality' is utterly dismissed.[12] Here's what Beckett favoured in Yeats over the idea of such expressivity in this painter's work:

> The being in the street, when it happens in the room, the being in the room when it happens in the street, the turning to gaze from land to sea, from sea to land, the backs to one another and the eyes abandoning, the man alone trudging in sand, the man alone thinking (thinking!) in his box – these are characteristic notations having reference, I imagine, to processes less simple, and less delicious, than those to which the plastic *vis* is commonly reduced …[13]

What Beckett is getting at is the idea that our understanding and appreciation of Yeats' art is irreducible to what the painter appears in his art to be seeing. The significance of Yeats' work, in fact, is not to be sought in its Irishness, in its captivation of some national essence or 'local substance', as he calls it, with which Yeats would have felt as one. Rather, it is the ambiguity – 'the alienation, suspension, disjunction' (to cite Lloyd[14]) – that resonates with Beckett's own aesthetic preoccupations that we must see as, along with the artist, we look.

A previous essay, 'Les Deux Besoins' (written in 1938) already set the stage for the notion of artist as visionary. And there Beckett identified art as interrogation: 'The artist poses questions, poses himself as a question, resolves himself in questions, in rhetorical questions without oratorical function'.[15] But it is not until the two subsequent articles that Beckett fully develops the contradiction that the interrogative nature of art presents: 'Finished, brand-new, the painting is here, a non-sense', Beckett wrote in 'La peinture des van Velde', confirming painting's accommodation of the inexplicable 'mess' or chaos of

existence. 'Ignorance, silence, and the motionless azure' – in other words, the non-critical, the non-explanatory stance to be taken by the viewer – offer the only possible solutions before the conundrum which the aesthetic accommodation to the ambiguity of life may be said to pose.[16]

'Les Deux Besoins' further develops the idea that art is the product of need. Insofar as the need to know and the need to need impel the artist to create, art as a fundamentally interrogative pursuit is not after beauty, but knowledge. It is not in the nature of man to know, however. And it is not in the nature of the artist to give up trying. Thus the critic's task is no more viable than the artist's assays at expression. It is for this that Beckett could admiringly write of Yeats' painting: 'High solitary art uniquely self-pervaded' and 'not to be clarified in any other light' but its own.[17]

Beckett's critical writings, in their absence of ideology or sustained judgment, in their disclosure of the paradoxes that seeing as the prototype of creativity implies, both reiterate and validate this thinking. Refusing to submit to the descriptive task of the reviewer, aiming more at a defence of art against the intellect, they propose to rescue art's legitimacy from speculation that erroneously posits art in objectivity and its function in expressivity. Offered in their stead is the only true pleasure art inspires: the immediate apprehension of the world, and the situation of the human being within it, through innovation all the more valid for its inexplicability.

Nonetheless, Beckett's own critical writings belie his belief in both the irrelevance of criticism to art and art's resistance to critical interpretation and valorization. His critical writings on the brothers van Velde, on Hayden, Yeats and others bring to light the very process of painting, a process that may be defined as an unveiling of *how* individuals see and *how* they make public the intimacy of their seeing. His capacity to do so was, in a sense, the consequence of a profoundly visual thinking. If a number of artists have chosen to illustrate Beckett's work, it is precisely because his use of the word was, in itself, 'painterly'. That his critical writings reveal so much of the visual experience of the painter is no doubt a consequence of the fact that his dramatic and fictive writing is strikingly imagistic and that it seeks thereby the illustrator's expression in visual form. Avigdor Arikha, Georg Baselitz, Edward Gorey, Stanley William Hayter, Dellas Henke, Charles Klabunde, Louis le Brocquy, Jasper Johns, and Robert Ryman have all created art that emanates from, as opposed to describes, Beckett's writings. Not subordinate to, but very much independent of the text, the work of these artists is in no way a 'burden to the story', as Klabunde has put it. Rather, Beckett's stories and the accompanying pictures are 'living reflections of each other'.[18] It is this very same relation that Beckett's critical writings bear to the visual art of which he writes so elegantly.

1 Samuel Beckett, 'Homage to Jack B. Yeats', *Disjecta Miscellaneous Writings and a Dramatic Fragment* (ed. R. Cohn) (Grove Press, New York, 1984), p. 149

2 Samuel Beckett, *Waiting for Godot* (Grove Press, New York, 1954), p. 48b

3 Samuel Beckett, 'MacGreevy on Yeats', *Disjecta*, p. 95

4 Cf. Peggy Phelan, 'Lessons in Blindness from Samuel Beckett', *PMLA* (October 2004), p. 1280

5 Samuel Beckett, 'La peinture des van Velde ou le Monde et le Pantalon', *Disjecta*, p. 123 (my translation)

6 Beckett, 'MacGreevy on Yeats', *Disjecta*, p. 97

7 Phelan 2004, p. 1280

8 Samuel Beckett, Letter to Axel Kaun, *Disjecta*, p. 172

9 James Knowlson, *Damned to Fame* (Simon and Schuster, New York, 1996), p. 187 and *passim*.

10 Lois Oppenheim, *The Painted Word: Samuel Beckett's Dialogue with Art* (University of Michigan Press, Ann Arbor, 2000)

11 Phelan 2004, p. 1280

12 David Lloyd, 'Republics of Difference: Yeats, MacGreevy, Beckett' in *Field Day Review* 1 (2005), p. 46

13 Beckett, 'MacGreevy on Yeats', *Disjecta*, p. 97

14 Lloyd 2005, p. 46

15 Samuel Beckett, 'Les Deux Besoins', *Disjecta*, p. 56

16 Beckett, 'La peinture des van Velde ou le Monde et le Pantalon', *Disjecta*, pp. 119 and 125

17 Beckett, 'Homage to Jack B. Yeats', *Disjecta*, p. 149

18 Charles Klabunde, Statement on *The Lost Ones*, *Review of Contemporary Fiction* (Summer 1987: 160), cited by Oppenheim 2000, p. 185

Beckett and the visual arts proceedings of a round table discussion

Held on Sunday 9 April 2006
National Gallery of Ireland

Chairperson:
Peggy Phelan, Ann O'Day Maples Chair in the Arts
and Professor of Drama and English at Stanford University

Panellists:
John Banville, Dellas Henke, Charles Klabunde,
James Knowlson, Rémi Labrusse and Breon Mitchell

Panellists' Biographies

JOHN BANVILLE's long list of publications includes a collection of short stories, a novella, and a recent non-fiction book, *Prague Pictures: Portraits of a City*, that came out in 2003. But it is his novels that are undoubtedly most familiar: *Birchwood, Doctor Copernicus, Kepler, The Newton Letter, Mefisto, The Book of Evidence, Ghosts, Athena, The Untouchable, Eclipse, Shroud,* and *The Sea. The Newton Letter* was filmed for Channel 4 Television and his adaptation of Elizabeth Bowen's *The Last September* was filmed for Scala Productions. Banville's version of Heinrich von Kleist's comedy, *The Broken Jug*, was staged at the Abbey Theatre in Dublin in 1994, and a short drama, *Seachange*, was broadcast the same year by RTE television. A one-man adaptation of his novel, *The Book of Evidence*, ran at the Kilkenny Theatre Festival in 2002, and had an extended run at Dublin's Gate Theatre in 2003. Among the many awards Mr. Banville has received for his novels are the Allied Irish Banks Fiction Prize, the American-Irish Foundation Award, the James Tait Black Memorial Prize, and the Guardian Fiction Prize. In 1989 *The Book of Evidence* was shortlisted for the Booker Prize and won the first Guinness Peat Aviation Award as well as the 1991 Italian Premio Ennio Flaiano award. *Ghosts* and *The Untouchable* were both short-listed for the Whitbread Fiction Prize, and *The Sea* was awarded the Man Booker Prize in 2005.

DELLAS HENKE is Professor of Printmaking at Grand Valley State University in Michigan where he has been teaching printmaking since 1982. Among his many works are several artist's books, including *Waiting for Godot*, published in 1979 with 13 etchings and signed by Beckett; *Company*, published in 1983 with 15 etchings and also signed by Beckett; and *Ill Seen Ill Said*, 1990, with 18 etchings. He has had 200 solo and group exhibitions, one of which was entitled 'Word and Image: Samuel Beckett and the Visual Text,' at the Musée des Beaux Arts in Caen, France. Henke's work is currently in over 75 public collections including the University of Reading, the New York Public Library, Yale University, the Library of Congress, the National Gallery of Art in Washington, DC, and the National Library of Canada in Ottawa.

CHARLES KLABUNDE is both a printmaker and a painter who has been the recipient of a Guggenheim Fellowship and honoured with awards from the New Jersey Council of Arts and the National Academy of Design, among others. His work has been selected for a great many solo and group exhibitions, including the Whitney Museum of American Art's show 'Five New York Printmakers', and is widely exhibited in prestigious public and private collections throughout the world. His etchings are in the collections of many major museums, including the Metropolitan Museum of Art, the Museum of Modern Art, the Whitney Museum, the Brooklyn Museum and the National Gallery of Art in Washington, DC. In the 1980s, in collaboration with the New Overbrook Press, he created seven etchings for a deluxe edition of Samuel Beckett's *The Lost Ones*. Charles Klabunde has taught at Cooper Union in New York and lectured at the Brooklyn Museum. He currently resides in Easton, Pennsylvania, where he maintains his private studio and gallery. Over the past two years, he has completed 50 large drawings and oil paintings for two series called 'Angels Without Gods' and 'Empty-ness of Laughter'.

JAMES KNOWLSON is Emeritus Professor of French at the University of Reading. He was a personal friend of Beckett for 20 years and wrote Beckett's authorised biography, *Damned to Fame. The Life of Samuel Beckett*, published in 1996. The book was short-listed for the Whitbread Biography Award and the James Tait Black Memorial Prize in Britain and was awarded the Southern Arts Association's prize for the best non-fiction work over a three-year period. In the USA, it won the George Freedley Memorial Award for the outstanding book on theatre of 1996 and it has now been translated into seven languages. Professor Knowlson has also written or edited ten other books on Beckett, including *Light and Darkness in the Theatre of Samuel Beckett* (1972), *Frescoes of the Skull: The Later Prose and Drama of Samuel Beckett (*written with John Pilling in 1979), and *Happy Days: Samuel Beckett's Production Notebook* (1985). He was the founder, in 1976, of the *Journal of Beckett Studies* and the creator, in 1971, of the Beckett Archive, now known as The Beckett International Foundation, a charitable trust at the University of Reading to which he remains an adviser. More recently, with the British theatre photographer, John Haynes, he published *Images of Beckett* (Cambridge University Press, 2004). His latest book is *Beckett Remembering – Remembering Beckett* (written with Elizabeth Knowlson) which has just been published for the centenary by Bloomsbury Publishing in the UK, Arcade Publications in the US and Suhrkamp Verlag in Germany.

Professor of Contemporary Art History at the University of Amiens, France, RÉMI LABRUSSE has written numerous essays on painting and painters as well as a number of interdisciplinary studies on art and the poetry of Baudelaire, Mallarmé and Yves Bonnefoy. He is a renowned specialist of Matisse and in 1999 Gallimard published his book *Matisse: La Condition de l'Image.* An essay, 'The Desire of the Line,' appeared in a volume on the plant drawings of Matisse and Ellsworth Kelly; several other essays on Fauvism and Byzantine art have appeared in exhibition catalogues throughout Europe and the United States. *Miró: Un feu dans les ruines* was published by Hazan in 2004 and another book on Matisse and Derain was published by Hazan the following year. Rémi Labrusse's connection with Beckett was the result of his work on the Byzantine art critic Georges Duthuit, son-in-law of Matisse and friend of Beckett.

BREON MITCHELL is Professor of Germanic Studies and Comparative Literature at Indiana University, where he also serves as Director of The Lilly Library of rare books and manuscripts. He received his degree in Modern Languages from Oxford University and his primary areas of research include the modern novel, the modern illustrated book, and translation studies. He has written, edited and translated over 20 books and monographs, including *James Joyce and the Modern Novel: 1922-1933*; *Beyond Illustration: the Livre d'Artiste in the Twentieth Century*; the co-edited *Word and Image: Samuel Beckett and the Visual Text*; and a re-translation of Franz Kafka's *The Trial* for Schocken Books.

PEGGY PHELAN is the Ann O'Day Maples Chair in the
Arts and Professor of Drama and English at Stanford
University. She writes frequently about contemporary
art, from performance to architecture and is the author
of, among other works, *Mourning Sex: Performing Public
Memories* (Routledge, 1997) and *Unmarked: The Politics
of Performance* (Routledge, 1993). She co-edited *The Ends
of Performance* (New York University Press, 1997) and
Acting Out: Feminist Performances (University of Michigan,
1993). Currently, she is writing a book entitled *Twentieth
Century Performance* for Routledge. Professor Phelan has
been a Guggenheim Fellow, a Getty Fellow, and a Fellow
of the Project on Death in America, sponsored by the
Open Society Institute of the George Soros Foundation.
Her essays about Beckett have appeared in the journals
Modern Drama and *PMLA*.

Albrecht Dürer seen through Samuel Beckett's eyes

JAMES KNOWLSON

Beckett had a huge admiration for the work of Albrecht Dürer. As a child, he had a reproduction of the *Praying Hands* of Dürer hanging on his bedroom wall at Cooldrinagh, his family home in Foxrock. He took copious notes on Dürer's life and work in the early 1930s and his 1936-37 unpublished German diaries prove his interest and admiration conclusively, although they also reveal some reservations about Dürer's art. On his February 1937 visit to Nuremberg, he went to look at Dürer's house, and on 2 March, Dürer's birthplace in Nuremberg. He faithfully recorded his impressions of all the Dürer paintings and engravings that he saw in Berlin, Leipzig, Dresden, Bamberg, Nuremberg and Munich. Even the brief glance we can take today at his comments on Dürer will lead us to touch on some fascinating relations with Beckett's own creativity.

Let us look first at a few of the paintings with Beckett's comments on them from his unpublished German diaries. The 1526 portrait of Jakob Muffel in Berlin's Kaiser-Friedrich Museum is described by Beckett in his diary as 'wonderful' (German Diaries (GD), vol. 4, 21 Jan. 1937) as is that of Hieronymus Holzschuher of the same year, described in the notes he took on a book (not yet identified) as 'his finest portrait'. (These Dürer notes are held, with copies of the German Diaries, in the Archive of the Beckett International Foundation in the University of Reading.) He bought the Berlin Gemäldegalerie catalogue with its many historical details about these 'admirable' (Beckett's word not mine: GD, vol. 3, 18 Dec. 1936) late portraits to feed his remorselessly inquisitive quest for facts, noting their date but also the fact that both of Dürer's two friends were 'Burgermeisters' of Nuremberg: 'Incredible fur and hair painting', he wrote of the Holzschuher painting (GD, vol. 4, 21 Jan. 1937) 'Portrait of young woman (1506, i.e. second Italian journey) also lovely with background of blue sea and sky' (*ibid.*). But Beckett is nothing if not discriminating, distinguishing regularly – sometimes with one word

judgments – between the good, the bad, even the ugly in Dürer, as elsewhere. In his comment on the *Virgin and Child with the Siskin*, for instance, in the old Kaiser-Friedrich Museum in Berlin – the siskin is a kind of finch, perched on the Infant's left arm (pointing its beak directly at the child's brow where the crown of thorns will one day rest) – he writes that the painter has produced a '*Disagreeable* Madonna with Siskin' (GD, vol. 3, 18 Dec. 1936). This painting is, Beckett adds knowledgeably, from Dürer's second Venice journey in 1506, and the *Portrait of a Young Girl [Wearing a Beret]* is 'ditto' (*ibid.*), meaning that it was painted after his Italian trip, not, as might at first appear from the syntax, that it is 'disagreeable'.

On his February visit to Nuremberg, he expressed great disappointment at the collection of Dürer he found assembled in the Germanisches Museum, pulling no punches in his dismissive remarks: 'A very poor effort … small characteristic portrait of Wohlgemut, the only essential Dürer in the entire collection' (GD, vol. 5, 27 Feb. 1937). He also wrote that the '*Beweinung* [or *Lamentation of Christ*] was so bad (Mary's left hand) as to be hardly even an early work' (GD, vol. 5, 28 Feb. 1937). And he went on, 'Hercules and Maximilian scandalous – any old rag that they could stick his name onto' (*ibid.*). He then voices two fascinating reservations about the German master's work. First, 'The Wohlgemut [is] archetypical but [he asks himself] how much is the best Dürer portrait not mosaic' (*ibid.*), a word that surely suggests the bringing together of disparate elements with doubts as to the integrity of the whole. Secondly, he proposes that the 'Nürnberger Burg not what it was in Würzburg or Bamberg, cut no ice, no prince of church tradition'. He suggests instead that it was 'Prematurely bourgeois. Guilds, not commissions. Hence at the best craft. [a rude word with Beckett] Meistermaler, Bildhauer, usw. Even in Dürer this feeling of the laboriously complacently jealously initiate. [Then he adds, amusingly and perhaps self-deprecatingly] Etc.' (*ibid.*).

But while trying to capture the immediacy and liveliness of Beckett's on the spot reactions to Dürer's paintings, drawings and etchings, we should not ignore much larger questions of how such comments relate to his own approach to art, even to his own writing.

Attention has tended to focus (when it has focused at all on Beckett and Dürer) on the impact that the engraving on copper *Melancholia I* of 1514 and the whole literary and iconographical tradition of melancholia exemplified by the Minnesinger poet, Walter von der Vogelweide's 'man on a stone', quoted in Beckett's last prose work *Stirrings Still* as well as elsewhere, exercised on Beckett. (See essays in particular by Giuseppina Restivo and Yann Méval). While he was in Germany, as Mark Nixon has recently pointed out in the *Journal of Beckett Studies*, Beckett was even attempting (and failing) to write a work called the *Journal of a Melancholic*.

But we should also note a much wider, though intimately related, affinity between Beckett and Dürer which can best be observed through his notes on the painting of the *Four Apostles* in Munich's Alte Pinakothek gallery. Beckett writes down lots of historical details about this superb picture but he concentrates more than anything else on the contrasting temperaments of the four figures, describing them in terms of the temperaments: 'Sanguine (John), phlegmatic (Peter), melancholic (Paul), choleric (Mark). Antithesis also between meditative (J & P with open book and key dominant) and militant (P and M with closed book and sword dominant)' (GD, vol. 5, 13 Mar. 1937). He went back several days later, adding in his note to the opposing temperaments and the open and closed books further oppositions: 'No eyes … . Eyes. Warm … Cool. Don't pursue antithesis into toes' (GD, vol. 6, 29 Mar. 1937). Now Beckett knew perfectly well from his earlier reading that the four figures could be seen as representing differing medieval temperaments. This fact was already in a sentence written in his earlier notes. But his development of these antitheses points to a fascination with underlying metaphysical, and especially elemental, themes; compare his earlier response to the ballet *Petrushka*, seen in London, when he talked about the philosophy behind the ballet rather than the ballet itself. Much of the buried intellectual infra-structure of Beckett's own plays tends to take the form of similar antitheses. *Godot* contrasts natural and mineral with the tree and the stone; earth is set in opposition to sky. In *Endgame*, stasis and movement supply the basic dynamics of the play. In *Krapp's Last Tape*, light is

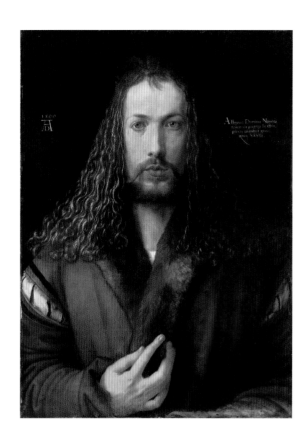

Fig. 42: Albrecht Dürer, *Self Portrait with Fur-Trimmed Robe*, 1500, oil on panel, 67.1 x 48.9 cm, Alte Pinakothek, Munich

opposed to dark, permeating both the textual imagery and the stage props. In *Happy Days*, yearning for movement up (potential escape by Winnie 'simply float up into the blue', 'up into the blue, like gossamer') contrasts with the dominant pull down into the earth, as Winnie sinks or is 'sucked down' into the scorched earth: earth and fire predominate. Next month an entire academic conference in Aix-en-Provence is being devoted to this elemental aspect of Beckett's writing.

Here, in conclusion, I want merely to pose a more general question as to the nature of the relationship between Beckett and Dürer's paintings. We are surely not dealing here with influence but, as so often in Beckett, with self recognition. Beckett found in Dürer's painting of the four apostles elemental contrasts that interested him greatly. They probably intrigued him so much because they rely on principles of construction which are subtle rather than self-evident or crude. After all, Paul, the melancholic, is a powerful figure in his own right, 'wonderfully' painted, as Beckett noted – 'the Paul wonderful' (GD, vol. 5, 13 Mar. 1937) – the eyes in particular are indeed extraordinary; Mark, the choleric, has a distinctive head that is vividly alive; Peter exercises a dramatic impact with his frown, his down-cast look, his furrowed brow. In fact the painting as a whole has some of the characteristics that were to emerge later in Beckett's own stage images: boldness yet subtlety of conception, leaving much for the listener/viewer to do; a solid intellectual infrastructure; and striking internal contrasts. If we add these elements to Beckett's long-standing interest in the melancholic tradition and his personal links with and experience of that condition, there is, I think, enough material to justify a more extended study of the affiliations and the distinctions between Beckett and Dürer. It was indeed intended to be a chapter in a book I was writing on 'Samuel Beckett and European Art and Sculpture'. Quitting the field entirely this week for a variety of reasons and abandoning that particular book, I hope someone more talented and more knowledgeable than I will take it up and explore it more thoroughly than this brief glance has permitted.

Samuel Beckett and Georges Duthuit
RÉMI LABRUSSE

I would like to develop one hypothesis which is half-biographical, half-aesthetic: although Beckett's love for painting was strong, beginning in early youth and lasting throughout his life, and although this passion is expressed in many of his letters, diaries and published works, his real commitment to thinking and writing about visual arts was limited to a relatively brief period of time, between 1945 and the early 50s, the time when Beckett first began to write directly in French.

Why was this period so intense and so short? Because writing and talking about art soon led Beckett to a radical distrust of art criticism as such, and, more precisely, of his own credentials as an art critic. Rejecting the literary transcription of a visual experience before a work of art, critiquing his will to express what happened in the viewing process, nearly led the writer to a theoretical rejection of the visual image itself, although he never distanced himself (Beckett never ceased to look at paintings with intense interest).

The grounds for this distrust were both ethical and aesthetic. He believed he was merely harming the painters he wanted to support, because he felt he was bound to distort the meaning of their works by likening it to his own obsessions; this was the case, most clearly, with Bram van Velde. Aesthetically, he understood that his intuitive, passionate response before what he felt to be a good painting could not be transcribed without destroying the picture. The original silent visual encounter with a work of art was properly '*unamable*'. As soon as it was accounted for, it became literature. In other words, the visual experience was the exact opposite of a narrative. However, the expression of this experience seemed bound to take the form of a narrative and to impose this structure on the image itself. Through this process, image became representation: the pure, bodily presence of forms was transposed into a story-telling process. The same is true for the viewer: his first experience before a painting is that of losing himself; but when he wants to express this feeling, all the psychological structures of the self reappear, and are

superimposed on the original experience. Remember what he wrote in 1945, apropos the two brothers van Velde: 'With words, we do no more than tell of ourselves'.

This complex, paradoxical experience with art writing can be linked with Beckett's friendship with the editor, art historian and critic Georges Duthuit, probably the most original, penetrating critic of the art of Henri Matisse, whose son-in-law he was. Duthuit's friendship first encouraged Beckett to overcome this pessimistic view and to revive a utopian, if paradoxical, hope of inventing a kind of non-expressive expressivity, which was to be found at once in his words and in Bram's visual forms. This utopian outlook, however, was soon to be undermined by a profound sense of doubt.

Duthuit, who was born in 1891, was fifteen years older than Beckett. From his youth on, he based all his life on a few central beliefs which had been instilled in him by a sort of English guru he met in Paris in 1910: this Matthew Prichard introduced him to the philosophy of Bergson, to the work of Matisse and to the aesthetics of Byzantine art. These references remained constant throughout Duthuit's career. At the end of 1947, he decided to revive the magazine *transition*, created by his friend Eugene Jolas before the war. He bought the title and transformed the journal into an English language magazine of contemporary French literature. There were four issues in 1948, one in 1949 and one in 1950. Beckett's contributions involved translating many texts from French into English, revising already existing translations, and submitting some writings to the journal. He always refused to be cited as translator in the publication, except in the case of his own texts.

Correspondence between Beckett and Duthuit started in 1947 and continued until the mid-1950s. This exchange of letters was particularly dense between 1948 and 1951. The high point was reached in 1949, and concerned their discussions about painting. More precisely, their friendship grew in March 1949, when Duthuit came back from a stay at André Masson's place near Aix-en-Provence, where he had long conversations with Pierre Tal Coat, another artist recently established in the city of Cézanne. By then, the idea of a written dialogue between Duthuit and Beckett

on the works of Masson, Tal Coat and Bram van Velde was born; it was to be published in December of the same year, with some reluctance on Beckett's part. He attempted to escape this task several times and put off the writing of his contribution to the very last moment.

Beckett also worked on the English version of some of Duthuit's own texts, for publication in English-speaking journals like *Art News*, *The Listener*, etc. Among these works, by far the most important was the translation of *The Fauvist Painters*, published by Robert Motherwell in New York in 1950. Beckett is not only present as a hidden translator in the book, he is also quoted several times by Duthuit in his text, with reference to Bram van Velde. It is also very likely that the Socratic questioner whom Duthuit rhetorically uses in his text under the name of Folevilius has much to do with Beckett and that the fictional dialogue thus created is fully reminiscent of their contemporary conversations.

The two men were not alone in these conversations, but were joined by a number of artists who formed a kind of group around them. Let us take Tal Coat as an example: when he writes to Duthuit, in March 1949, that he is haunted by an 'idea of nakedness, lessness, loneliness' and that he 'feels more and more inclined to become a man of few words', one cannot but think of Beckett's thinking of the period (even if the artist and the writer had not yet met at that time). Although Beckett had probably introduced the van Velde brothers to Duthuit, he was himself most indebted to his friend for his new social life in the Parisian art world. It was through Duthuit that he could dine at Matisse's place in Paris and see the master's old or later works; that he met Northern Americans like Francis and Riopelle; and, most importantly, that he became friends with Giacometti, whose work seemed to him much more appropriate than de Staël's for the *Waiting for Godot* set. Giacometti, who is described by Beckett in a letter as 'granitically subtle' and 'full of staggering perceptions', whereas Beckett vehemently opposes 'De Staël ideas about the set' as a kind of preciousness or 'Wagnerism', a point to which I will return shortly.

Both Duthuit and Beckett had the same goal in mind: not really one artist or another, one style or one school

against another, but the mimetic aesthetics of the Western Renaissance as such, consecrating the artist as a genius, a creator of fully realised masterworks. This is what Beckett identifies as 'the plane of the feasible', of 'puny exploits', 'of pretending to be able' and what Duthuit, for his part, rejects as the world of 'representation', where the image tends to substitute itself for the life experience. As a counterpart to this, both men believed in a kind of weakening of the image, a sort of *kenosis*.

Finally, what is probably most significant is their common sense of the uniqueness of the encounter between artwork and viewer. Both had continuously shared, throughout their respective lives, a kind of intense inner emotion before an image which had always aroused in them a sense of release from their egos. This experience was physical, sensuous, originally deprived of any representational constraints: this is why Beckett has so often been depicted lost for hours in contemplation before a painting, silent and motionless. In those moments, any urge to represent, any expression of the ego would have been overcome by a primal sense of awakening, of coming into Being. Therefore, any kind of expression was doomed to remain derivative, divorced from this original inexpressible intensity and, to some extent, unfaithful to it.

Nevertheless, Beckett's and Duthuit's views about art were irreconcilable. They can be characterised as two utopian positions, one negative, the other positive, one rooted in a sort of extreme romantic ontology (Beckett), the other leaning towards a phenomenology of pure subjectivity (Duthuit). Duthuit's Bergsonian inspiration led him to describe subjectivity as an uninterrupted flow, not as a structural entity. Here lies the core of his discussion with Beckett: is an image bound to be ontological? Is its fate, its doom, to reflect the appearance, or the essence of things? Or, if we just change our own ways of seeing, can we not be delivered from the question of Being? This is to say that they are not speaking from the same point of view: Duthuit's main concern is with the process of perception. What interests him is the eye, not the image; the way we look, not the way we paint. Beckett's main concern is with the process of creation (or expression, in his own words). He wants to characterise

the essence of the image, not its action on the viewer; he is speaking of the relationship (or the absence of relationship) between the image and the structure of being, not of the relationship (or the absence of relationship) between the image and the structure of perception.

A consequence of this period of intensive theorising about art was that Beckett clearly kept art criticism out from his oeuvre and continuously repeated from then on that his art essays were only accidental and in fact worthless. The painful experience of the *Three Dialogues* (which end with the famous: 'Yes, yes, I am mistaken, I am mistaken') led him to revile himself in the role of art critic. In his letters to Duthuit in 1949, he wrote repeatedly that he would not go further in this direction: 'I will keep trying but I won't go on much longer. I've done everything in my power for Bram, that's it now. The harm I've done to him is also behind us'. The only thing he wished to make clear, he said, was 'his utterly bad opinion of his own role in the van Velde story'.

One may even wonder whether a distance did not appear between Beckett and the visual perception of art? Let us go back to his criticism of de Staël's ideas about the set of *Waiting for Godot*. In Beckett's view, the artist was seeing the work on a theatrical set as a 'continuation of painting'; on the contrary, he declared to Duthuit that he greatly disliked this kind of 'Wagnerism' and wanted 'a kind of theatre limited to its own means, words and acting, without painting or music, charmless', adding: 'I don't believe in collaboration between the arts. I might be a Puritan [Protestant]. I am what I am. Do you really believe that it's possible to pay attention to a play in front of a set by Bram?'. At this stage, Bram's work seems to have been reintegrated into the realm of conventional artistic creation, as opposed to the radical decreation the writer had fantasised about; again, a letter to Duthuit attests to this growing disillusion: 'With him [Bram], there will only ever be the beauty of effort and failure, instead of the one, so quiet and even cheerful, by which I pretend to be haunted'. The same is true of painting in general, as Beckett wrote in 1950, from Dublin: 'I just spent an hour re-visiting the National Gallery with MacGreevy. Saw a couple of old friends again, from the time when I thought I loved painting'.

Beckett's early conception of the visual image was utopian and romantic. It was more or less replaced by his puritan and somehow melancholy conception of theatre: his theatre plays in the 1950s could be seen as a sort of continuous bereavement of the intense utopian stance expressed in his writings of 1945-50. He accepted that literature was cut off from the more original silent truth encountered before works of art. In his letters to Duthuit, his self-suspicion already undermines what he still declares – even if reluctantly – in his texts on Bram van Velde. Take these sentences in a letter to Duthuit, for example: 'The acceptance of ignorance, of pure weakness is least likely to be found among the daubers and pen-pushers. Here I hold my tongue'. Holding his tongue, falling silent: this is exactly what Beckett, from then on, decided to do in front of pictures, and one might suspect that he considered this position, this experience, one of the most genuine in his life time, far remote from the growing buzz surrounding his theatre plays and other writings.

In Beckett's own words…
JOHN BANVILLE

As I am sure many of you will know I am a rank amateur here. I am not a critic, I am not an academic. I am merely a reader. As a reader, my contention is that Beckett is an old- style landscape artist, certainly in his novels anyway. I hope the previous speaker will forgive my indulgence of Wagnerism. Few support my view, and Beckett is thought of as a man who deprecated nature. There is a wonderful morning-fresh piece in *From an Abandoned Work* which I wish he had not abandoned. It simply says something about his relationship to nature:

> Oh I know I too shall cease and be as when I was not yet, only all over instead of in store, that makes me happy, often now my murmur falters and dies and I weep for happiness as I go along and for love of this old earth that has carried me so long and whose uncomplainingness will soon be mine. Just under the surface I shall be, all together at first, then separate and drift, through all the earth and perhaps in the end through a cliff into the sea, something of me. (*From an Abandoned Work*, in *Collected Shorter Prose 1945-1980*, John Calder, London, 1988)

I think that one of Beckett's finest works – and I suppose it is in a way my favourite, certainly of his prose works – is the late piece *Ill Seen Ill Said* which I think is a masterpiece of world literature, and will come to be seen as such in time. I think it has not been recognised yet for its quality. Again here he shows how wonderfully he could paint – he was a great admirer of the Dutch Masters. This is a winter scene which I think is absolutely ravishing in its economy and poignancy as the old woman lives and is dying:

> Winter evening in the pastures. The snow has ceased. Her steps so light they barely leave a trace. Have barely left having ceased. Just enough to be still visible. Adrift the snow. Whither in her head while her feet stray thus? Hither and thither too? Or unswerving to the mirage? And where when she halts? The eye discerns afar a kind of stain. Finally the steep roof whence part of the fresh

fall has slid. Under the low lowering sky, the north is lost. Obliterated by the snow. The twelve are there.
(*Ill Seen Ill Said*, in *Nohow On*, John Calder, London, 1989)

In an earlier work, the wonderfully mordantly comic *Watt* there is a wonderful section where a gentleman in a fine full apron with green baize delivers what he describes as a short statement which lasts for 26 un-paragraphed pages. And even though Beckett is, or the man in the green baize apron is, describing the world as a dreadful place – 'a cats flox' – he, Beckett and the man in the apron, manage to portray the seasonal round with the loving particularity of a Hobbema or Ruisdael or even a Brueghel. This is a little piece from *Watt* which I love both for its landscape painting and for its wonderful comedy:

The crocuses and the larch turning green every year a week before the others and the pastures red with uneaten sheep's placentas and the long summer days and the newmown hay and the woodpigeon in the morning and the cuckoo in the afternoon and the corncrake in the evening and the wasps in the jam and the smell of the gorse and the look of the gorse and the apples falling and the children walking in the dead leaves and the larch turning brown a week before the others and the chestnuts falling and the howling winds and the sea breaking over the pier and the first fires and the hooves on the road and the consumptive postman whistling *The Roses Are Blooming in Picardy* and the standard oillamp and of course the snow and to be sure the sleet and bless your heart the slush and every fourth year the February débâcle and the endless April showers and the crocuses and then the whole bloody business starting all over again. (*Watt*, John Calder, London, 1963)

It is a well-known piece, but I think it is nice to revisit it. Finally, I think one of the most beautiful passages in all of Beckett's prose is from *Malone Dies*. Despite Beckett having more than something of the night about him, there are very few night pieces in his work. This is one of those

wonderful rare nocturnes in which, as I say again, I think he is painting a portrait. One of the reasons I was reading here today was to get Beckett's words in amongst ours and this, I think, is one of his most beautiful passages:

There was nothing, not even the sand on the paths, that did not utter its cry. The still nights too, still as the grave as the saying is, were nights of storm for me, clamorous with countless pantings. These I amused myself with identifying as I lay there. Yes, I got great amusement, when young, from their so-called silence. The sound I liked best had nothing noble about it. It was the barking of the dogs, at night, in the clusters of hovels up in the hills, where the stone-cutters lived, like generations of stone-cutters before them. It came down to me where I lay in the house in the plain, wild and soft, at the limit of earshot, soon weary. The dogs of the valley replied with their gross bay all fangs and jaws and foam. From the hills another joy came down, I mean the brief scattered lights that sprang up on their slopes at nightfall, merging in blurs scarcely brighter than the sky, less bright than the stars, and which the palest moon extinguished. They were things that scarcely were, on the confines of silence and dark, and soon ceased. So I reason now, at my ease. Standing before my high window I gave myself to them, waiting for them to end, for my joy to end, straining towards the joy of ended joy.
(*Malone Dies*, in *The Trilogy*, Calder and Boyars, London, 1966)

Beckett and one visual artist

DELLAS HENKE

I am at a little bit of a loss knowing where to begin talking about work that I began more than half a lifetime ago. I often wonder if artists should be banned from talking about their own work or if we are obliged to do it. I am not really sure. I have to trust my hosts on this one. I am going to talk not so much about Beckett and the visual arts but Beckett and one visual artist and just tell you a little about my dealings with him and his work.

I began reading Beckett in college in the mid-1970s and I was pretty quickly hooked or, maybe better said, mystified. It was the seemingly impossible combination of humour and horror and his ability to turn nothing into a clear voice that amazed me. It caught my attention. It made it possible for me to imagine a way to function in the blandness of America's suburbia where I grew up. In graduate school I had the fortune of having a studio mate who also loved Beckett and as we worked together and needled and scraped on our etching plates, we often quoted or paraphrased long sections of *Godot*. It was at this time that I had the crazy idea that I wanted to illustrate *Godot*. I was 23 years old, and I had no idea what that really meant. It certainly was naive and a bit arrogant but I am glad I did it.

First, I had to learn to set type. This was done the old fashioned way with lead type and so I took a typography class and made a terrible little book. I then took an independent study class and had to convince the people at the University of Iowa to let me use their type and their presses for what was going to be a two and a half year project. I went to Ken Merker who ran Windover Press at the University of Iowa to ask for the type and the press. I remember him looking up from his desk and saying 'ok kid, you can have the type, but you have to get Beckett's permission', and I think he did not think I would get it. And *I* did not think I would get it. But Iowa being a great creative writing school, I started asking around because the first thing I had to do was get Beckett's address. It turned out Charles [Klabunde], who I did not know, was the man who had it. Once I had the address, I made five or six

etchings, a couple of dozen drawings and set two or three pages of type. I bound them together in a kind of dummy copy and sent them off to Paris. I had no idea what was going to happen but amazingly ten days later I had a letter in my hand that gave me permission to reprint it. So then I set out to work. I was a graduate student at the time doing a lot of other work, and I actually kept the project from my major professor because I wanted this to be something done on my own. To some people's consternation all 40 or 37-odd copies of the book are different. I think the title page says 12 etchings by Dellas Henke and some copies say 13 or 14 or 15. I changed the order all the time. They are all different.

I do not know how true it is, but my understanding of Beckett was that he was a stickler when it came to how his theatre was performed, but that with many of the artist's books that had been done, he kept his hand out of it and he really had no idea what was going to happen with them. Other people I have talked to that have illustrated his work felt the same way, so it seems that at least somewhere in his life he was willing to let go of control of things, and that certainly helped me.

Godot led to the University of Iowa becoming interested in making books like that. So working with the fledgling 'Iowa Centre for the Book' we made *Company*. It was wonderful because I did not have to do all the type setting and all the printing. People who were a lot better at it than I was did that part of the work. I just collaborated on design, I made the etchings and I printed them back in Michigan. I had a wonderful binder called Bill Anthony who was a fifth generation Irish binder who the University of Iowa had working for them. So that book was really, really a deluxe edition.

When that book was finished, I went to Paris with the title pages and the remaining title pages from *Godot* and then had one of those crazy, magical, impossible-to-believe afternoons sitting in a hotel with Samuel Beckett. When he walked in there was silence and we stared at each other and then I realised he may have been as shy as I was about it, and that broke the ice. He signed the books and somehow he stayed for two or three hours while we chatted about dumb stuff, like coffee. He made fun of

Fig. 43: Dellas Henke, 'Do you think God sees me?', 1979, *Waiting for Godot*, etching on paper, 20.3 x 15.7 cm, National Gallery of Ireland

American coffee, but I told him you get free refills and he was amazed by that. He wanted to know a lot about my father who had landed at Normandy and fought his way all across France before being wounded a few miles inside the German border. That conversation took up a good part of the afternoon. I knew it was a genuine interest because his questions about my father and the war did not end. I do not know why he had an interest, but that is a lot of what we talked about.

I think that Beckett's support for projects with young artists, like me at the time, was really his way of helping other artists when there was a way he could. He did not teach or he tried briefly, and it did not work too well, I understand, but it seems that he tried to help people whenever he could.

I have not thought too much about this work for a long, long time. I am making fewer prints now and doing a lot more photography and I did not think about the relationship between what I am doing now and what I was doing then. Now, I am shooting landscape, often in the American southwest, and these are the kinds of places where Godot could be hiding. They are bleak, they are barren. I do not know why I am drawn to those places, or to Michigan where I live. It is a big fruit-growing area and I have been photographing a lot of cut-down orchards where the ancient trees are sort of in a pantomime. They remind me of Estragon, hopping on one foot – both funny and grotesque at the same time. This kind of landscape is disorientating. I think (as Professor Knowlson said) that Beckett recognised himself in Dürer and I think that I recognise myself in Beckett's landscapes.

Beckett and the artist's book
BREON MITCHELL

The artist's book (*livre d'artiste*) is a genre that is particularly tied to the twentieth century. It consists generally of a text by an author, images produced in an original graphic form and a book that is sometimes produced by the artist and sometimes separately by a publisher. Because of the nature of these books and because they use original works of art in them – etchings or engravings or woodcuts or lithographs – they are necessarily limited in the number that are produced so you have, as a rule, not more than 100 or 120 of these and often they are even more strictly reduced. As I will say a little later, that leads to certain problems. I can say immediately that one of the problems it leads to is that most people never actually see and read these books. They see reproductions of some of the images in the books but they seldom see the books themselves.

I am interested in these artists' books, both for what we might learn about Samuel Beckett from them, and the ways in which they might illuminate or enrich our readings of Beckett's texts. Finally, I am interested in them as, in a sense, undiscovered treasures that still slumber in private collections or in institutions and I would encourage some of you to awaken them by going to those institutions and looking at some of these very special books.

Let me begin by saying something about Samuel Beckett and the artist's book. In the 20th century there probably is not another major writer, and certainly not one in the English speaking world, who has been so closely involved with artists' books or had so many of his texts result in artists' books. We have over 30 different books that have been produced in this way with Beckett's agreement in every case and often with his involvement. The range of artists involved, and I just mention a few here from a list – Avigdor Arikha, Max Ernst, Edward Gorey, Stanley William Hayter, Jasper Johns, Louis le Brocquy, Robert Ryman, Bram van Velde – those are only a few of the total and they give you some sense of the international scope and the variety of artists that are represented in these books.

What was Beckett's interest in the artist's book? Did he merely grit his teeth and agree to allow his works to be illustrated? Was it simply friendship with artists who were at that time close to him and quite well known? Was it a generous spirit on his part, with totally unknown artists at the time, that he would from time to time give permission and texts too? Or was it something else which has yet to be fully explored? Beckett's relationship to these artists' books could have been simply one of 'all right, you have my permission, go ahead and illustrate this work'. It could have been, but it was not. In many, many cases Beckett provided a text; not that he would necessarily write a text to be illustrated, but he would select a text which had not been published and give it to a particular artist. He also would often visit the studios, particularly of course of his friends, as these books were under production. He would sit with them, he would look at the works of art as they were being produced, and he would discuss those works with them. Not in every case but in several cases, he showed a deep interest in what was happening as these books were being created.

I give you three examples in which Beckett actually put his hand into the process, not as an artist, but put his hand into the process of creating such a book. Avigdor Arikha, for example, who has one of the longest lasting relationships with Samuel Beckett as a visual artist and as a creator of such artists' books, was producing the text illustrations – etchings – for the text *Au loin un oiseau*, and one of those he focused on as a concrete image was a coat. As Jim [Knowlson] has pointed out, Beckett was not satisfied with the coat that Avigdor had selected to use as a basis for the etching and said 'No, no it's not that, not that, it's got to be another coat', and another coat was found, and Beckett said 'Yes, that's the coat', and that is the coat from which the etching was actually made.

When Beckett was speaking with Stanley William Hayter, Hayter showed him the original basic ideas for his illustrations or etchings for the text *Still* which Beckett gave to Hayter for that particular artist's book and Beckett looked at the portrait and said 'No' (there's a portrait partly of Beckett that is hidden in the work, it comes out more clearly in the proofed copies of the etchings than in the

actual coloured etchings themselves). He said it needed to be more like a marionette in some way. So Hayter went back, did it in another way and what we have now is a result in which you can see that idea of the marionette in the work itself.

There was another sort of involvement for Jean Deyrolle, who had produced a number of texts of illustrations and etchings and drawings for text that was called *Séjour*. In that case Deyrolle died before the book itself could be produced and so out of a total of 32 original drawings that were to be transformed into etchings Beckett himself selected the five that appear in the book. So here we have a case in which out of 32 possible images relating to his work we know he selected these particular five.

What can we gain from these books now? I think we can gain some further understanding of Beckett and his attitude towards the visual arts. But I would also like to suggest that each of these books represents an artist's reading of a particular text by Beckett. And because they are visual readings of Beckett's texts by very creative people whose minds are rich in themselves, they can often illuminate or enrich the text in the way that criticism perhaps from another direction might do for us. I have been in the fortunate position of having had together, and of having been able to look through and read, all of the artists' books that we know of that have illustrated Samuel Beckett's work. On many occasions, I found that I have learned from looking at those illustrations some new aspect of Beckett's text which I might have learned from an academic essay, I might have learned from reading the text several times myself, or I might never have learned at all.

Finally, I want to close by suggesting that these artists' books are not simply image and word together but that they are created as aesthetic objects in themselves: there is paper, there is layout, and there is topography and bindings. One of the largest artist's books is Bram van Velde's for the *Texte Pour Rien, 13*. Hans Martin Erhardt created a book so big you cannot hold it on your lap; you have to put it down on a table to go through it, of *Act Without Words*, I & II. Several of Beckett's smallest texts have resulted in the largest books. These books do not exist until they are read and reading does not mean looking at the illustrations as reproduced, but it means actually having them and turning the pages and seeing the relationship of word and image in the context of the book as a whole. In a sense if they are not read they are like unplayed music, and as in the case of music where you need a performer to play, in the case of these artists' books, the performer has to be the reader. It is a performance you have to go through yourself.

Many of these great books that Beckett himself was interested in, and in some cases had a direct and intimate relationship to, have not been read in the sense that they have never actually been performed as a work of art by more than a handful of people. That is too bad, because these are sometimes wonderful artists and the Beckett texts are always wonderful.

I want to close by encouraging all of you to go to those libraries that have these artists' books'. You can see them, you can have them brought to you and you can actually read them and perform them, and you will be the benefiters then of some very special experiences.

Klabunde's *The Lost Ones*
CHARLES KLABUNDE

When I look east and when I look west I see dark clouds. I see a religious fanaticism coming to our country. It is frightening to think that modernity with all of its wonders cannot produce a spiritual reality. Maybe Beckett can do that for us.

The question we have to ask ourselves as artists and creative writers and musicians is how do we get this relevance that Samuel Beckett gave us, that is so direct and demanding, into an affirmation of our societies and our life in modernity?

In 1974, I went to see my old mentor Mauricio Lasansky who had a great influence on American printmaking. After I won the Guggenheim Fellowship and did the *Seven Deadly Sins*, he suggested that I write to Samuel Beckett to illustrate one of his works because my iconography is such that it represents existential matters of the 1950s and 1960s. When I wrote to Beckett I gave him slides of the *Seven Deadly Sins*. He said that he found them fascinating, and that I could illustrate one of his texts if I went through Barney Rosset at Grove Press. So I walked over to Barney Rosset because he was across the street in Greenwich Village, and we talked for a while. The text I really loved was *How It Is*, but it is so difficult to try to imagine how to illustrate, because it is about crawling through the primal slime of consciousness until you make contact with another being. So I decided *The Lost Ones*, which Beckett had won the Nobel Prize with, would be an excellent piece to work with and we did seven etchings. Unfortunately, I just did the drawings because it took ten years – sort of a Beckett journey – to find the right party to do it, because if you are going to do something with a great man, you want to do it right. At the Cooper Union School of Art, I met Stephanie Wise. Her cousin Charles Altschul had just finished Yale University and he was in typography and he wanted to do a book because his grandfather, Frank Altschul, had run Overbook Press. Stephanie introduced us and I showed him my drawings and I told him that I had this old letter from Beckett that said we could work with him and the reality became real.

Fig. 44:
Charles Klabunde,
'The Relatives',
The Lost Ones, 1984,
etching on paper,
44.5 x 29.5 cm, National
Gallery of Ireland

We worked on the project for over a year. I printed each print so they are all hand printed. The text is Gill Sans, all hand typed. The book is in beautiful Belgian vellum and it was an honour, a real honour, to finish that project. At a celebration party we had for Beckett in New York we were all asked to give a little note to Beckett because it was his birthday and I just put down, 'Thank you for being part of my consciousness', and somehow or another he wanted to meet me. So Michael Fried came along into my life. He ran the Roundabout Theatre which has done many Beckett plays. And we went to France to see Beckett and we spent two days in a hotel on the Boulevard Saint-Jacques. When Beckett came in, I said to him, 'I finally made it' and in his usual Beckett way he said, 'You are almost too late'. And I was almost too late.

He looked at my work. We talked. I felt his pain, I felt his nihilism and I felt pretty bad. And that was a transitional point in my life. I decided I could no longer be an existential nihilist: I could no longer deal with images that were terrifying, horrifying, without affirmation if we were going to be a positive force on our culture, and then I became an existential realist. What is an existential realist? That is a good question, I suppose it could take hours here and we could throw baseball bats at each other trying to figure that one out but in truth maybe I should describe my last two series to give you an idea. I saw some ballet dancers and I formed them into angels and the angels existed only if we believe in them. If we stop believing in them, they cease to exist because we know that the angels all live above the clouds. They live in space, and space seems infinite. God is not going to destroy this earth: maybe a chunk of ice, a nova or our own foolish behaviour. So I do not know where we are going, but certainly it is nice to believe that this wonderful world would be pretty much empty without us because we are unique.

The other series is about women who are incarcerated in a Louisiana prison who had the dignity to put on costumes; Mardi Gras, Halloween. They demanded to be individualised in this terrible world of incarceration and they represented what *Godot* or *Endgame* represents to me; the voice demanding to be heard even in our isolation. When people look at them they get the chills, and that is

a very complimentary feeling to me. I had the wonderful experience of someone calling me up from Silver Springs, Maryland, who was going to come up and buy one of my etchings. She was totally paralysed and her husband brought her in a wheelchair and she decided to buy the 13th piece of the *Empty-ness of Laughter* which was a great temptress who was actually a model from a *Vogue* magazine seducing poor children and women into their madness. She also bought two angels that were embracing each other, and I was so touched by the fact that she was so incapacitated and yet could live within my work. That is worth more than any museum curator's compliment or critic's compliment because that is what we have to do as artists: we have to redefine our reality to the challenges that are coming from both the fundamental Christian world and the fundamental Muslim world, because we have to prove that modernity has a soul, a spirit and a power and then maybe we will find ourselves again.

Beckett and Avigdor Arikha

PEGGY PHELAN

Thanks to the strength of Beckett's argument in 'Three Dialogues,' and his support for the work of the Bram and Geer van Velde, there is a strong sense in Beckett studies that he loved abstraction and abstract expression. But I think this argument overlooks a very important aspect of Beckett's visual sensibility. Jim Knowlson and Lois Oppenheim have helped show the immense range of Beckett's interest in art, from Dürer, Caravaggio and Rembrandt, through Caspar David Friedrich, to Jack B. Yeats, Alberto Giacometti, through to Edward Gorey, Robert Ryman and Jasper Johns, and this of course is only a short list. In the little time I have today, I want to sketch briefly some aspects of Beckett's friendship and collaboration with the painter Avigdor Arikha, in my view one of the very best painters working today. Many of you have probably seen at least some of Arikha's portraits of Beckett; there is a fantastic etching from 1972 on your ticket today, and in the last few years, several of the portraits have appeared on book covers, including the beautiful books, *Drawing on Beckett*, edited by Linda Ben-Zvi, and Ruby Cohn's *A Beckett Canon*.

Beckett and Arikha met in 1956. The painter was 27 and the writer was 50. Their friendship was fundamental for both men, and it continued until the end of Beckett's life. In the course of their friendship, Arikha did a series of drawings and engravings of Beckett, most of which were made between 1965 and 1983, that the art critic Robert Hughes described as 'the most significant set of portraits we have of any 20th century artist'. When I first read Hughes' claim I thought perhaps Hans Namuth's portraits of Jackson Pollock are more significant, primarily because they show the artist at work, but then I thought again and thought that perhaps Beckett's deepest labour was to rest, and this is what some of Arikha's portraits give us.

In 1956, however, when Beckett and Arikha met, the painter was pursuing abstraction, the most influential genre of contemporary painting at the time. Interestingly, Arikha has told Duncan Thomas that Beckett would look at these paintings and say, drily, 'Still in the tunnel I see'.

It is an interesting and brilliant comment, although perhaps also a surprising one. In works such as *The Fall* from 1958 and *Forms II* (1965), Arikha's exhilarating investigation of colour and shape perhaps was also employed in the service of blotting out, or muffling, other memories, other shapes – shapes he had drawn as a boy in the internment camps of Eastern Europe. The complex story of Arikha's life is too difficult for me to summarise here, but suffice it to say that Arikha made a small book of drawings while he was interned and this book and its subsequent discovery enabled Arikha and his sister, Lea, to be rescued. The book was returned to Arikha by the International Red Cross in 1960 and he has allowed some of the images to be reproduced. Arikha's work and life allow us to think of abstraction as a response to trauma, one rooted in a rejection of the obeisance often involved in mimesis. I am not suggesting that we begin to think of abstract expressionism as purely psychological symptom – the best paintings are too beautiful to be addressed by terms derived from medical discourse and the bad ones do not rise to the density of psychological or political expression – but I am suggesting that abstraction be seen in a framework supple enough to suggest that part of its appeal comes from the possibility it exposes of refusing to accept the order of visible things. This was abstraction's essential appeal for Beckett, who saw theatre as an arena to 'write paintings' as Billie Whitelaw, one of his most gifted stage interpreters, put it. To conceive of drama as a way to write paintings is to avoid the theatre of individual psychological development that had become the dominant quest of modern drama. In its place, Beckett repeatedly sketched the drama of the social relation and the ethical tension of living with blindness that stretched far beyond the specific optical difficulties of Pozzo or Hamm. For both Arikha and Beckett, the question of seeing was simultaneously an ethical, aesthetic, and deeply intimate one.

Arikha retained from abstract expression, and especially from the lesson of Pollock, a conviction about the force of immediate observation. Painting with no pre-drawing or formal outlining, put it, like theatre, in the perilous hit or miss situation we associate with live performance. Arikha's

ability to draw quickly is well known; he draws and paints with astonishing fluidity and never revises, describing his process as a kind of summons, 'like a telephone call – when it rings, I run'. This kind of blindingly fast speed suited Beckett, whose intense self-consciousness made sitting for a portrait unbearable. Arikha was interested in the limits and possibilities of the quick glance and remarked, 'Painting from life, in its submission to observation, a given space and time, by restricted means, is a sort of seismic trace. It's provisional, but intensive' (interviewed by Barbara Rose in *Avigdor Arikha Oil Paintings, Watercolours, Drawings* exhibition catalogue, Marlborough Fine Arts, London, 1978). Arikha's portraits of Beckett gave him a chance to see himself coming into coherence via the hand and eye of his friend. While this would be a rich psychic experience for anyone, I think for Beckett it had a special resonance and depth. The delicate impression and the precision of Arikha's engraving and drawing line allowed his portraits to be both blank and definite, both open and contained. Moreover, as Arikha returned again and again to the task of drawing Beckett, he seemed to draw Beckett's own confidence out, as an image of a person to whom one might return. This repetition, the re-encounter with the task of expressing what it is to see the face of one's friend, parallels Beckett's continual return to the difficult and exhausting labour of saying what is seen, even when the only thing to see is 'the whole face hidden'. When the portraits began to be exhibited and became known, many would remark how much the portraits looked like Beckett, to which he would wryly reply: 'I do my best'.

All of Arikha's portraits of Beckett are centred on his face, even when the whole face is hidden. For this reason, Arikha's portraits of Beckett might be usefully seen as an instantiation of the philosopher Emmanuel Levinas' contention that it is in the face-to-face encounter that the intersubjective nature of identity is realised. Such identity points to the infinite alterity of the other; 'the Other becomes my neighbour precisely through the way the face summons me, begs for me, and in so doing recalls my responsibility, and calls me into question.' (Levinas, 'Ethics as First Philosophy' in *The Levinas Reader*, ed. Sean Hand, Blackwell Press, Oxford, 1989, p. 83).

Arikha did a portrait of Levinas – the philosopher of the face-to-face encounter – and positioned his own gaze at an angle to the philosopher's. The difficulty of facing the other is in every way related to the recognition that, more often than not, what we must confront is 'the whole face hidden'. Thus for both Arikha and Beckett, the question became not so much 'abstraction *or* figuration' but rather how to make vivid the space between these two modes of expression. How might the suspension between the specific constraints of time and space, and the timeless encounter with the same questions about existence and observation with and of the other, be made central in contemporary painting, even if that centrality did not express itself as visible shape or form? Might colour, scale, or feeling convey this state of suspension? When Arikha was a student studying in Jerusalem, one of his teachers was Isidor Ascheim, who admonished his students: 'Think that you may die in the middle of a line, therefore you must leave it perfect' (in Duncan Thomas, *Arikha*, Phaidon, London, 1994, p. 22). Such words entered the ears of Arikha, who had been so close to so much death for so much of his life, with extraordinary force and it took him a long time to get out from under the weight of that kind of will-to-perfection.

This quest was also central to Beckett's project and his admonishments to fail better might be seen as a response to his version of this same drive. I am sorry we have so little time to go into all of this today, but let me just quickly end these remarks by looking at Arikha's extraordinary painting, *Sam's Spoon*, that he made about a year after Beckett's death.

The whiteness of *Sam's Spoon* evokes the whiteness of 'dim dread' that had preoccupied both Arikha and Beckett for some time, and seems to spoon it, to fold it back on itself in the manner of a comforting hand. Beckett had given the spoon to Arikha's daughter on her birth, and one imagines that gift as both largesse and unburdening. Arikha had painted the white cloth several times before but in *Sam's Spoon* the cloth is unfolded, although the creases remain visible. Indeed, the lines of these unfolded folds suggest a kite flying, and one senses both the innocent games of children and the folded nature of the beyond to which Beckett's body now belonged. (See Duncan Thomas'

extraordinary essay on *Arikha, op. cit*. His essay has profoundly influenced my own understanding of Arikha's work.) Here, the 'Endgame' Arikha gave Beckett was one in which Hamm's stauncher is at last unbloodied, and is at last free from the effort to see through blindness.

In 1967, Beckett wrote a text for the announcement card advertising Arikha's exhibition, which would include some of the portraits of Beckett. Beckett's text, originally written in French and then translated by him into English, reads: 'Siege laid again to impregnable without. Eye and hand fevering after the unself. By the hand it unceasingly changes the eye unceaselessly changed. Back and forth the gaze beating against unseeable and unmakeable. Truce for a space and the marks of what is to be and be in face of. These deep marks to show'. At once a meditation on his own portrait, and a statement of allegiance with Arikha's effort to move within the space of seeing's impregnable face, Beckett's text also subtly evokes the repetitious quality of drawing itself. Drawing accumulates line after line in order to show, like words themselves, deep marks. Lumps and furrows, ditches and orifices: the words and the lines prop us up as we try to see what it is to face seeing, the daring act that, for both artists, became the central drama of post-war life.

Fig. 45: Avigdor Arikha, *'Samuel Beckett (1906-87), seated, author and playwright'*, 1972, etching on paper, 21 x 10.5 cm, National Gallery of Ireland

List of exhibits

Beckett and the National Gallery of Ireland

After Adriaen Brouwer (c.1606-1638)
The Foot Doctor, after 1638
Oil on panel, 31.8 x 27.5 cm
National Gallery of Ireland (NGI 356)

Flemish School (formerly attributed to the Master of Tired Eyes)
Portrait of a Woman, c.1540
Oil on panel, 31.1 x 24.1 cm
National Gallery of Ireland (NGI 903)

Perugino (Pietro Vannucci), (c.1448-1523)
The Lamentation over the Dead Christ, c.1495
Egg tempera and oil on panel, 169.5 x 171.5 cm
National Gallery of Ireland (NGI 942)

Nicolas Poussin (1594-1665)
The Lamentation over the Dead Christ, 1657-60
Oil on canvas, 94 x 130 cm
National Gallery of Ireland (NGI 214)

Don Silvestro dei Gherarducci (1339-1399)
The Assumption of St Mary Magdalene, 1380s
Egg tempera and gold leaf on panel, 161 x 82 cm
National Gallery of Ireland (NGI 841)

Gerard ter Borch (1617-1681)
Four Franciscan Monks, c.1647-48
Oil on canvas, 71.7 x 95.5 cm
National Gallery of Ireland (NGI 849)

Pieter de With (fl.1650-60)
A Wooded Landscape after Sunset, c.1650-60
Pen in black, wash in grey, bodycolour, with white
and gold highlights, on paper, 16 x 27 cm
National Gallery of Ireland (NGI 2101)

Letters from Samuel Beckett to Thomas MacGreevy dated
(27) August 1932 and 13 (September 1932), TCD MS 10402
Trinity College Dublin, Manuscripts Department

Beckett and Jack B. Yeats

Jack B. Yeats (1871-1957)
Low Tide, 1935
Oil on canvas, 61 x 91.5 cm
Dublin City Gallery The Hugh Lane

Jack B. Yeats, (1871-1957)
Two Travellers, 1942
Oil on canvas, 92.1 x 122.6 cm
Tate, London

Jack B. Yeats (1871-1957)
The Graveyard Wall, 1945
Oil on canvas, 46 x 61 cm
Sligo Municipal Collection, The Model Arts and Niland Gallery

Jack B. Yeats (1871-1957)
Old Walls, 1945
Oil on canvas, 46 x 61 cm
National Gallery of Ireland (NGI 4716)

Jack B. Yeats (1871-1957)
The Music, 1946
Oil on canvas, 61 x 91.5 cm
Private collection

Letter from Samuel Beckett to Thomas MacGreevy
dated 31 January 1938, TCD MS 10402.
Trinity College Dublin, Manuscripts Department

Letters from Thomas MacGreevy to Jack B. Yeats
dated (November) 1930 and 22 December 1930
National Gallery of Ireland, Yeats Archive

Expanding Horizons

Karl Ballmer (1891-1958)
Kopf in Rot, 1930/31
Oil on canvas, 67 x 59.5 cm
Aargauer Kunsthaus, Aarau

Paul Cézanne (1839-1906)
Montagne Sainte -Victoire seen from les Lauves, 1905/06
Watercolour on paper, 36.2 x 54.9 cm
National Gallery of Ireland (NGI 3300)

Albrecht Dürer (1471-1528)
Melancholia I, 1514
Copper engraving on paper, 24 x 18.7 cm
The Chester Beatty Library, Dublin

Caspar David Friedrich (1774-1840)
Two Men Contemplating the Moon, 1819/20
Oil on canvas, 34.9 x 44.1 cm
Gemäldegalerie Neue Meister, Staatliche Kunstsammlungen Dresden
[provisionally scheduled for display during the final month of
the exhibition]

Jean Lurçat (1892-1966)
Decorative Landscape, 1932
Oil on canvas, 188 x 129.5 cm
Dublin City Gallery The Hugh Lane

Edvard Munch (1863-1944)
Two Women on the Beach, 1898
Woodcut, coloured with green chalk, 45.5 x 51.1 cm
Rijksmuseum, Amsterdam

Salomon van Ruysdael (c.1600-1670)
The Halt, 1661
Oil on canvas, 99 x 153 cm
National Gallery of Ireland (NGI 507)

Letters from Samuel Beckett to Thomas MacGreevy dated
8 September 1934 and 18 January 1937, TCD MS 10402
Trinity College Dublin, Manuscripts Department

Beckett's Collection (and Beckett's art criticism)
Avigdor Arikha (b.1929)
The Golden Calf, 1956
Oil on canvas, 50 x 27 cm
The Beckett International Foundation, University of Reading

Avigdor Arikha (b.1929)
Samuel Beckett (1906-87), seated, author and playwright, 1972
Etching on paper, 21 x 10.5 cm
National Gallery of Ireland (NGI 20904)

Henri Hayden,
Vue sur Signy Signets, 1962
Oil on canvas, 50.3 x 64.5 cm
Private collection

Jean-Paul Riopelle (1923-2002)
Composition, 1962
Gouache on paper, 50 x 65 cm
Private collection

Bram van Velde (1895-1981)
Untitled, 1936/41
Gouache on card, 125.8 x 75.8 cm
Centre National d'Art Contemporain Georges Pompidou, Paris

Bram van Velde (1895-1981)
Untitled, 1937
Oil on canvas, 100.2 x 81.2 cm
Centre National d'Art Contemporain Georges Pompidou, Paris

Geer van Velde (1898-c.1977)
Composition, 1937
Gouache, watercolour and ink on paper, 23.8 x 30.7 cm
Private collection

Jack B. Yeats (1871-1957)
Corner Boys, c.1910
Watercolour and gouache on paper, 36 x 25 cm
Private collection

Jack B. Yeats (1871-1957)
A Morning, 1935-36
Oil on board, 23 x 36 cm
National Gallery of Ireland (NGI 4628)

Jack B. Yeats (1871-1957)
Regatta Evening, 1944
Oil on canvas, 23 x 36 cm
Private collection

transition, 1949
(contains Beckett's 'Three Dialogues with Georges Duthuit')
The Beckett International Foundation, University of Reading

Derrière le Miroir, 1946
(contains Beckett's 'Peintres de l'Empêchement')
The Beckett International Foundation, University of Reading

Artistic Affinities
Louis le Brocquy (b.1916)
Ecce Homo, 1958
Oil and river sand on canvas, 115 x 80 cm (AR03)
Private collection

Alberto Giacometti (1901-1966)
L'Homme qui Marche, 1960
Bronze, 180.5 x 23.9 x 97cm
Fondation Alberto et Annette Giacometti, Paris

Alberto Giacometti (1901-1966)
Man at a Table, 1954
Pencil on paper, 59.5 x 41.7cm
National Gallery of Ireland (NGI 19336)

After Alberto Giacometti (1901-1966)
Reconstruction by Gerard Byrne of the tree Giacometti
sculpted for the 1961 production of *Waiting for Godot*
at the Odéon Théâtre de France, Paris

Joan Mitchell (1926-92)
Painting, 1958
Oil on canvas, 101 x 90.8 cm
Ulster Museum, Belfast

Artists' Books
Avigdor Arikha (b.1929)
Au Loin un Oiseau
Published New York: Double Elephant Press, 1973
With 5 original etchings by the artist
One of 90 numbered copies signed by Beckett
The International Beckett Foundation, University of Reading

Louis le Brocquy (b.1916)
Stirrings Still
Published London: John Calder; New York: Blue Moon, 1989
Original quarter parchment and natural linen over boards,
in original slipcase
With 1 original two-colour lithograph and 8 original
lithographs in black and white by the artist
One of 226 numbered copies, signed by Beckett and the artist
Private collection

Stanley William Hayter (1901-1988)
Still
Published Milan: M'Arte Edizioni, 1974
Text in English and Italian, translated by Luigi Majno
With 3 original signed etchings in colour, and 3 original
black and white signed etchings, by the artist
National Gallery of Ireland (NGI 11,424)

Dellas Henke (b.1954)
4 original signed etchings from: *Waiting for Godot*
Published Iowa City: Iowa Center for the Book, 1976
National Gallery of Ireland (NGI.2006.1-4)

Charles Klabunde (b.1935)
The Lost Ones
Published [Stamford, Connecticut]:
The New Overbrook Press, 1984
With 7 original signed etchings by the artist
One of 250 numbered copies, signed by Beckett
National Gallery of Ireland (NGI.2006.5.1-7)

Photographic credits